CONTENTS

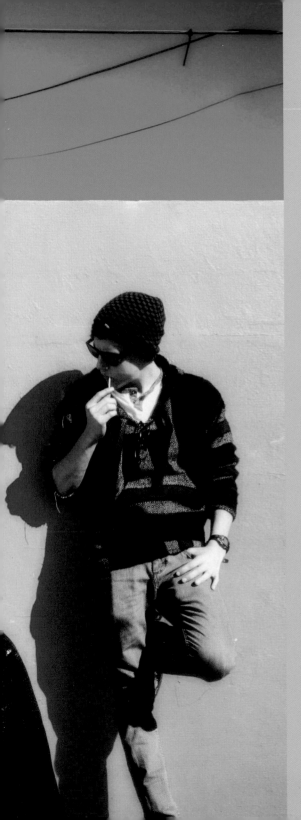

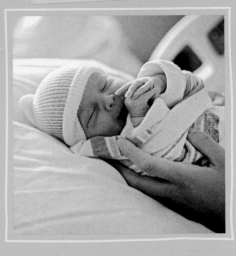

Introduction 06

THE BASICS

My Story 10
How to Use This Book 12
Snapshots vs. Photographs 14
Fundamental Photographic
 Concepts 16
The Rules 17
Basic Creative Principles 24
A Conversation about
 Camera Choices 32
Software & Post-processing 36
Sharing, Printing, & Storing 38

BABIES

The First 48 44
Early Days 46
Feeding Time 52
Sitting Up 54
Crawling 55
Bath Time 56
First Steps 57
Play Time 58
Sleep Time 60

KIDS

Creative Visualization 64
Schedule a Photo Shoot 68
Lighting & Time of Day 82
Sports & Activities 86
Quiet Time 92
The 'Tween Years 96
Teenagers 100
Posed Portraits 104

FAMILY

Come As You Are 108
Get In The Picture 110
Siblings 114
Comfort Zone 116
The Back Yard 117
Seasons 118
In The City 124
Around Town 126
On Vacation 128
The Classic Family Portrait 130
Holidays 132
Pets 134

Wrapping it Up 138
Resources 140
Index 142
Picture Credits 143
Acknowledgments 144

INTRODUCTION

FROM THE TIME my father gave me my first camera when I was 16, taking pictures was all I ever wanted to do. The camera was an old Nikon circa 1970—film, of course—and I think it weighed 11 pounds (at least it felt like it did hanging around my neck). I photographed all of the adventures of my youth with that camera: portraits of friends; mountaintops, sunsets and beaches; landscapes and streetscapes; self-portraits and pets. I shot everything I did and everywhere I went for years, but it wasn't until my children were born, that I found the true meaning and purpose in what I wanted to photograph.

Family: No matter what it means to you, chances are at some point you've been inspired to photograph yours. In this book I'll share my approach for creating meaningful photographs of your family that you'll be proud to share and treasure forever. You'll learn concepts that will not only improve the quality of your family photos, but will broaden your appreciation for the art of photography in general. I'll show you how I approach photographing the different ages and stages of childhood and "family-hood," to create your own beautiful collection of family photographs that go beyond mere snapshots.

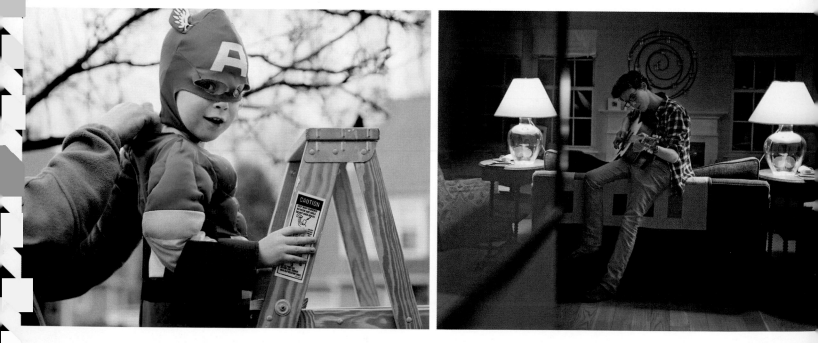

This would be me. Don't get too used to hiding behind the camera— you're a part of your family too!

THE BASICS

Photography is defined as the art or process of producing images by recording light (or other radiant energy) on a sensitized surface, such as film or an optical sensor. While it seems complicated at first, after breaking it down a little bit, it becomes quite simple. Whether you're shooting with a film camera, a digital SLR, a point and shoot or a camera phone, the concepts are the same. There are three main ideas (ISO, shutter speed, and aperture) that one needs to learn to understand of the basics of photography. Once you have a grasp of what they are and how they relate to each other, the only thing left to explore is your own creativity.

REAL LIFE
FAMILY PHOTOGRAPHY

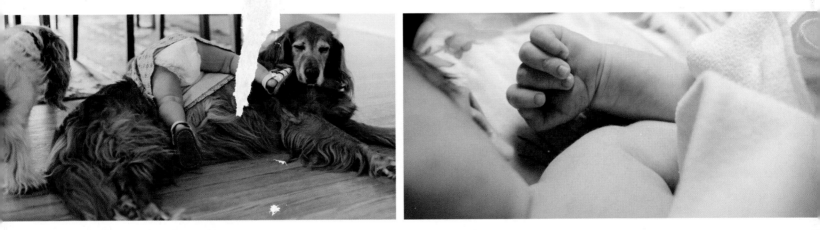

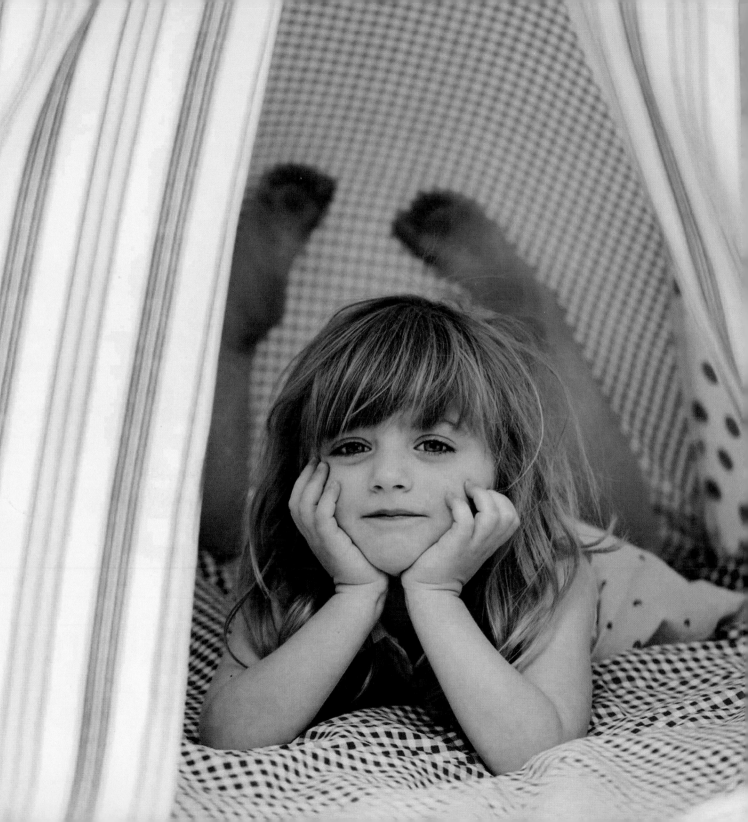

AMY DRUCKER

REAL LIFE
FAMILY PHOTOGRAPHY
CAPTURE LOVE & JOY THROUGH THE AGES & STAGES

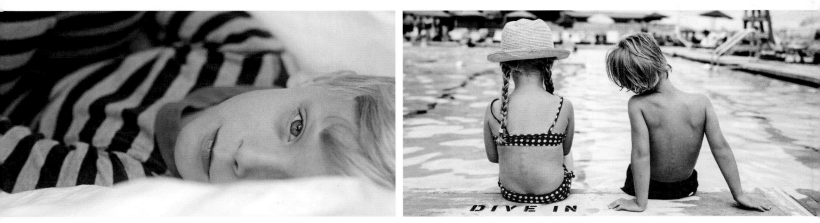

TO MY CHILDREN, JAKE AND QUINN: YOUR COMBINED LIGHTS
SHINE SO BRIGHTLY THAT MY DAYS ARE NEVER DARK.

ilex

An Hachette UK Company
www.hachette.co.uk

First published in the United Kingdom in 2016 by
ILEX, a division of Octopus Publishing Group Ltd
Octopus Publishing Group
Carmelite House
50 Victoria Embankment
London, EC4Y 0DZ
www.octopusbooks.co.uk

Publisher: Roly Allen
Associate Publisher: Adam Juniper
Managing Specialist Editor: Frank Gallaugher
Senior Project Editor: Natalia Price-Cabrera
Assistant Editor: Rachel Silverlight
Art Director: Julie Weir
Design: JC Lanaway
Senior Production Manager: Peter Hunt

Front cover: TR, © Pons Photography;
BR, © Lena Antaramian (Live Love Laugh Photos)
Front flap: B, © Gina Cooperman
Back cover: TR, © Gina Cooperman;
BC & BR, © Stocksy.

ISBN 978-1-78157-297-9

A CIP catalogue record for this book

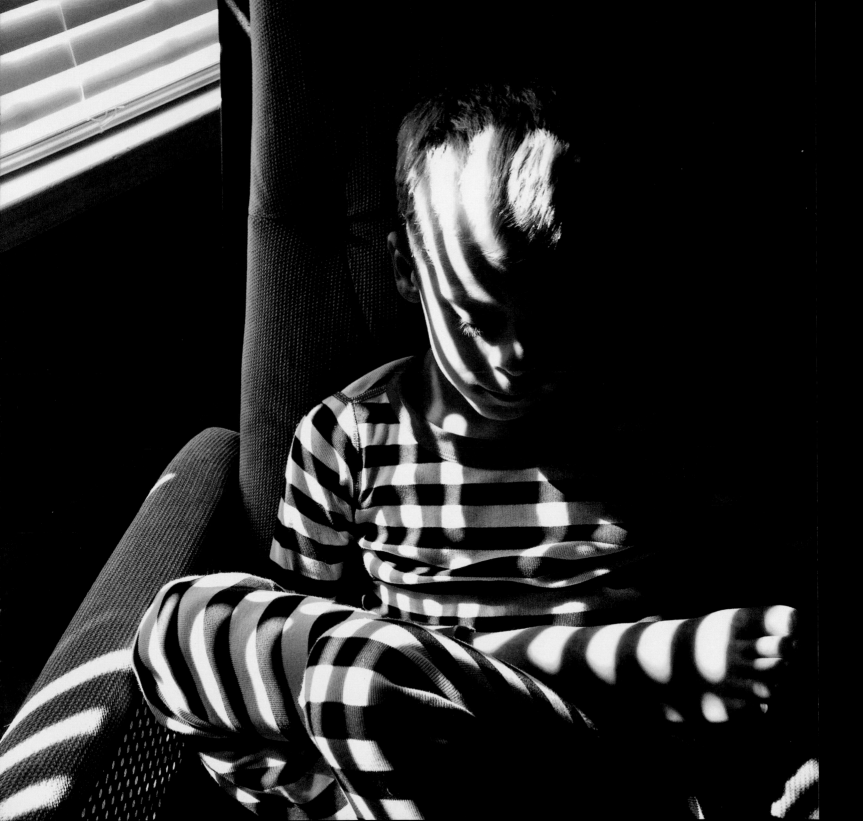

MY STORY

I GREW UP SURROUNDED by photographs. My father was a hobbyist photographer and, for as long as I can remember, my brother and I were accustomed to having our pictures taken—a lot. Family snapshots lined the walls of our home and thick leather photo albums filled up the shelves. I spent hours pouring over the photo essays in the pages of the *Life* magazine issues that arrived every week, and I was fascinated by how those images could tell stories. Photography was an intrinsic part of our lives.

When I started taking pictures of my kids, my love for photography solidified. For me, it wasn't just about all of the major milestones and predictable photo-ops (though, I certainly got my camera out for those, too). I couldn't get enough of photographing the tiny details that made up who my kids were, and which told the story of how we spent our days together as a family. I wanted to remember the way my son stuck just the tip of his tongue out of the corner of his mouth when he was concentrating or how his eyes squinted shut when he laughed.

Life with kids isn't simple. It's messy and fun, busy and wonderful, happy and frustrating, and a million other things, and I want my photographs

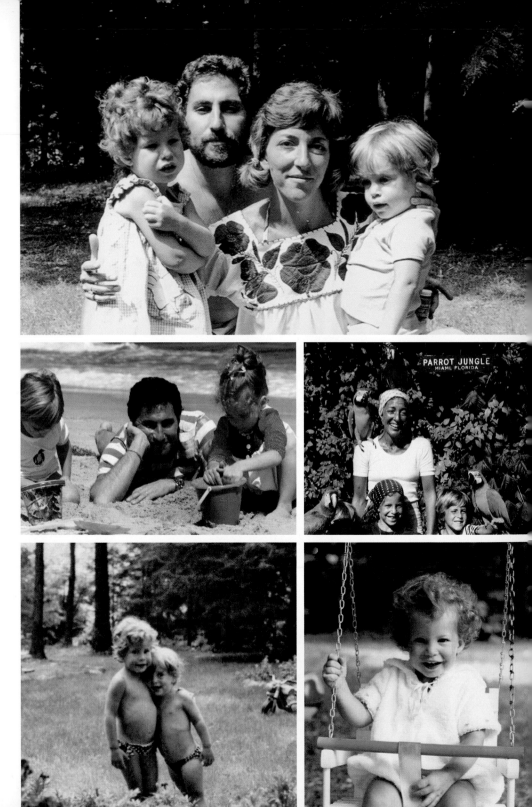

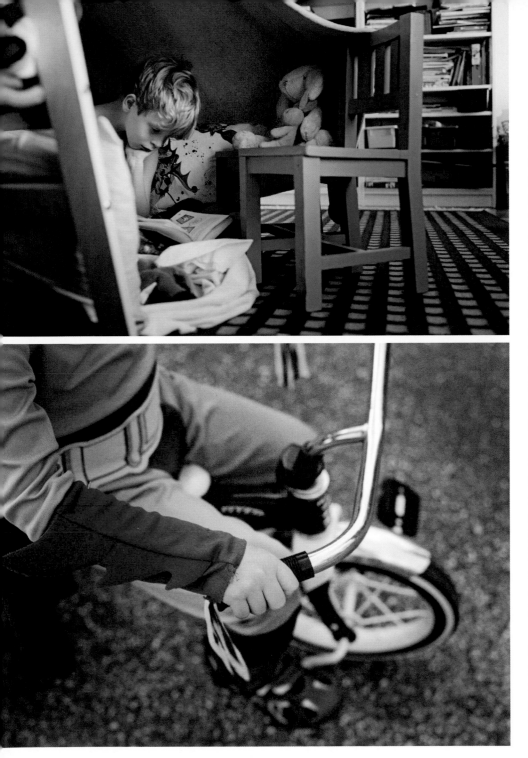

to be about all of it. So I take pictures, lots of them, every day. I admit that some days it's a bit of a chore and there are times that I have to force myself to do it, but I never regret it. And what I've learned after so many years of documenting our lives together is that even during the longest February day when everyone is grumpy and the car has a flat tire, and there's nothing but macaroni for dinner, and there are piles of dirty laundry everywhere, there is still something beautiful, some detail worth remembering. If I don't stop and look, it's likely to be gone in a blink, right along with my son's love of superheroes ("Mom, I'm so over that.")

The biggest mistake most parents make when it comes to photographing their children is waiting for the right moment. The moment, they think, when everyone is all cleaned up and tucked in, and ready to smile for the camera. But how much of your life with kids is really like that? It's a rhetorical question, of course. I have two boys, so I already know the answer: none!

So, if you want to take pictures of your family that capture the essence of what your family actually feels like, come with me through the ages and stages, and let me show you how to see what's photo-worthy in your world.

HOW TO USE THIS BOOK

WHO, WHAT, WHEN, WHERE, AND WHY? You already know who you're going to photograph, and I've discussed my philosophy on why. Now, we're going to cover the how, when, and where.

Let's imagine you're a photojournalist. Your job is to document a year in the life of your family. At the end of the year, you need to show your editor a variety of shots that will tell the story of your family's year. There will be birthday parties and dance recitals, and lost teeth, and those things should absolutely be included, but there will also be shoes tied every morning and teeth brushed each night. There will be stories read and tears shed, and snuggles had, and all of it is part of the story.

There are no rules, no specific boundaries or set number of pictures you have to take for this assignment, but it might mean an adjustment about how you approach photographing your family—a small step outside your comfort zone. Instead of remembering to take your camera out

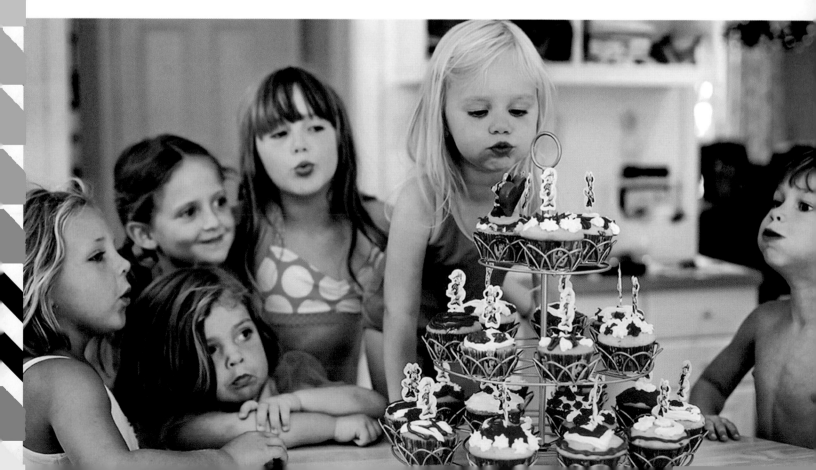

only for celebrations, you'll need to dust it off and spend some time with the manual. Charge up the batteries and keep it nearby—always.

The idea here is that you're training yourself to look between the big, milestone moments to the small, in-between ones that make up every single day. After some practice, this looking will become second nature and you'll find that your life is enhanced by your ability to see beautiful moments in the midst of ordinary days.

If, at first, it doesn't come naturally, don't worry. That's what this book is for—to give you some guidance. In the chapters that follow, you'll find suggestions designed to get you started that tell you where to look during each age and stage. Once you're more comfortable with the practice of it all, you'll begin to scout out and notice the moments in your own life that mean something to you.

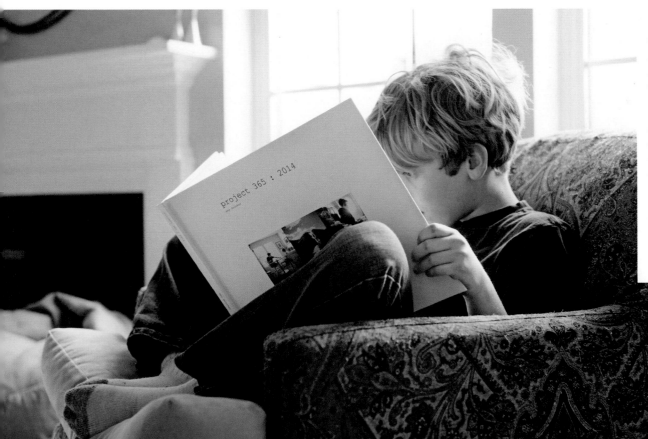

When I first began a daily photo project, I assumed that it was for the future. I hoped that one day down the road my kids (and their kids) would enjoy seeing what our lives were like "back in the day." As it turns out, though, the payoff was much sooner. My kids love looking through the albums of our years, right now, and reminiscing about "the day you took that photo."

SNAPSHOTS VS. PHOTOGRAPHS

A SNAPSHOT IS ANY PICTURE that speaks to a moment in time. It can be achieved with any camera at all and might be lacking in technical perfection, but is important to you nonetheless.

I'm not here to tell you that every picture you take has to be perfect. In fact, it's really just the opposite. I want to encourage you to just keep photographing, but I also want to help you make pictures that transcend time and place—photographs that you will want to hang on your walls or pour over in photo albums or share with your friends.

At this point, it's probably clear that this book isn't a crash course on the technical stuff. Hundreds of other books have gone there before, and much better than I could for that matter. The truth is, my work is less about technical perfection than it is about subject matter and vision, and that's just fine with me because that's where my heart lies. It really helps, though, to have some basic understanding of what elements make up a great image, as well as some fundamental comprehension of basic photographic techniques.

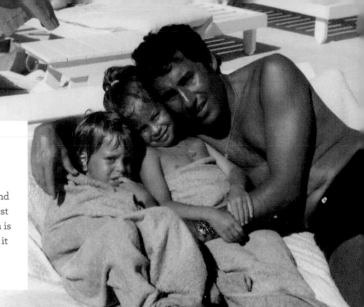

Here is a snapshot of my father, brother, and me on vacation in Florida circa 1974. Everyone is squinty and our expressions are just "eh." The composition is lacking, but I treasure it nonetheless.

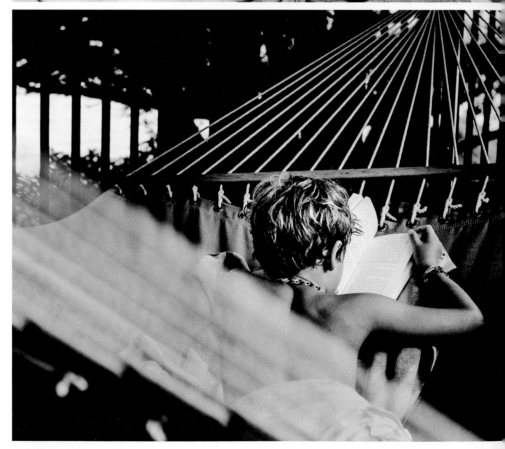

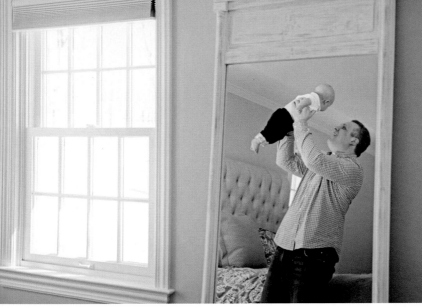

ELEMENTS OF A GREAT PHOTOGRAPH

While a successful photograph doesn't have to have every one of these attributes, great photographs often have more than one.

• An engaged subject
• Appealing light
• Compelling composition
• Correct exposure
• Crisp focus
• Intentional depth of field
• Correct colors or black and white

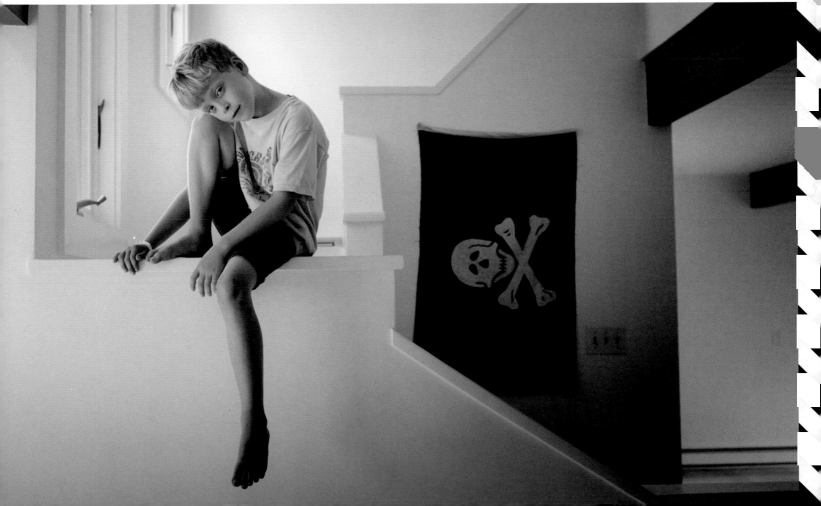

FUNDAMENTAL PHOTOGRAPHIC CONCEPTS

I WOULDN'T BE SURPRISED if your instinct was to skip this chapter completely and get right to the business of taking pictures of your kids. That's probably what I would do! The truth is, it's fine to go ahead and do that. Find the chapter that pertains to the stage you're going through right now and look for some inspiration. Read through the corresponding text and pick up your camera. Go ahead. Then, have a look at the images you've shot and come on back here.

I'm a firm believer that a huge part of taking better pictures has to do with actually just taking pictures (practice, practice, practice), but it's also true that the more photographic theory you understand, the more specifics you know about how to operate your camera, the more knowledge you have about what makes (and breaks) a good image, the better the chances that when you actually do pick up your camera, you'll come away with a photograph that looks like what you saw through your viewfinder.

Remember that rules in photography are really just guidelines and starting points. It's a good idea to understand the basic ones before departing from them, but after that, you're limited only by your creativity.

Sometimes the "spray-and-pray" method of pointing your camera in the direction of the action, firing off a bunch of frames, and hoping for the best works out in the happiest of ways—a great photo! But it's certainly not a method to be relied upon.

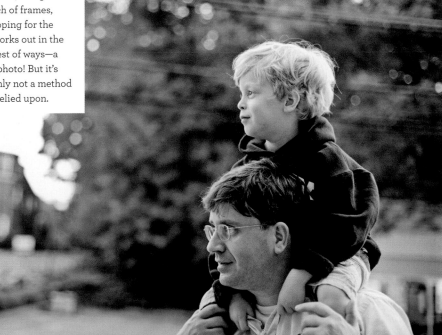

THE RULES

In photography, not unlike other art forms, there are basic rules and guidelines that can help to provide a foundation on which to build your image. There are all kinds of legitimate creative reasons to break the rules, but for your final image to be intentional, it's important to have an understanding of why the rules exist before departing from them. Happy accidents are certainly a welcome surprise, but let's talk about how to make them the exception and not the rule.

EXPOSURE

In its simplest form, exposure is not a complicated concept. The exposure of an image refers simply to the amount of light in the scene that you record with your camera to create a picture. Sometimes you'll hear people talk about "correct exposure," but in reality that is a misnomer. "Correct" implies that there is a right and a wrong way of exposing an image. While there certainly are guidelines, exposure can (and should) be a creative choice. When discussing correct exposure, it's commonly understood that the details in all areas of your image are clearly visible. If an image has both highlights and shadows, each should be exposed so that the shadows are not pure black and the highlights are not pure white.

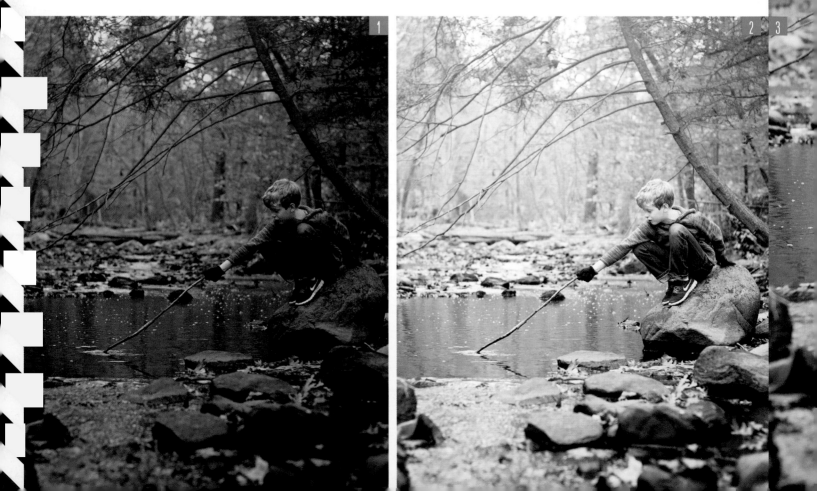

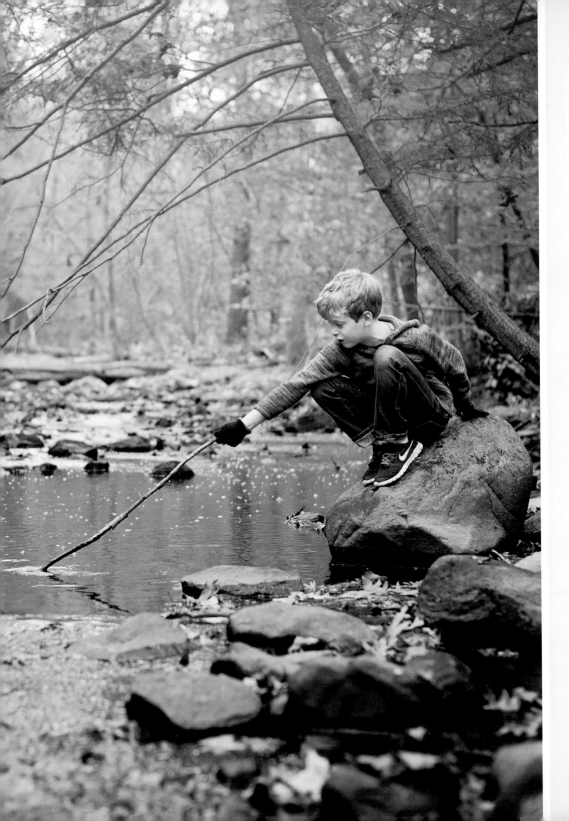

UNDER- & OVEREXPOSURE

The image on this page (3) would be considered properly exposed. Note that the lighter areas and the darker areas all retain detail. The image far opposite (1) would be considered underexposed. Note the general darkness to the image and the lack of details in the darkest areas. Finally, image 2 would be considered overexposed. Note the general brightness and the lack of detail in the lightest parts of the image. There are all kinds of creative reasons why a photographer would want to depart from a standard exposure so it's valuable to understand the concept—how your camera exposes an image and how to manipulate exposure so that your final image appears as you see it in your mind's eye.

THE EXPOSURE TRIANGLE

All cameras use three main factors to determine exposure (commonly referred to as the exposure triangle): the length of time the shutter is open (shutter speed), the size of the opening in your camera's lens that allows the light to flow through (aperture), and the sensitivity of the camera's sensor to light (ISO). All three of these can be manipulated and programmed to create the effect you desire.

No matter what the settings (whether you select them or you allow the camera to do that), the process is the same: the light reflected at the camera is recorded on the sensor. The more light that reaches the sensor, the brighter the resulting image; the less light, the darker the image will be. The goal is to allow a precise and calculated amount of light to reach your sensor in order to create the look you want for your photograph.

APERTURE

While none of the elements of the exposure triangle are more important than any other and each is integrally related to the other two, aperture is often considered to be the creative anchor of the trio. To understand how aperture works, we must first define the term "depth of field" (DOF). DOF refers to how much of an image is in focus. A shallow DOF means that a small portion of the image is in focus and a large DOF is exactly the opposite, with sharpness throughout. Aperture is your camera's way of controlling DOF.

The aperture blades of your camera's lens can open very wide or close down to a tiny pinhole. Actually, they work a lot like the pupil in your eye. Consider what happens to your pupils when you are in bright sunlight, or when a light gets shined in your eyes. Your pupil shrinks. Conversely, in a dark room, your pupils open as wide as they can to allow in the most amount of light possible. In photography, aperture is expressed in f-numbers (for example f/2.8). These values are commonly referred to as f/stops. A smaller f/stop means a larger aperture and a larger f/stop means a smaller aperture. For a lot of people, this scale seems counterintuitive and I can tell you that it took me a long time to wrap my head around it. Opposite is a diagram that might help you visualize the relationship between aperture size and f-number.

HOW THE APERTURE WORKS

Here you can see it plainly: small apertures leave more in focus, and wider apertures limit the plane of focus to a thin sliver (in this case, the toes of the two kids in the grass).

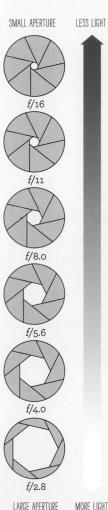

SMALL APERTURE LESS LIGHT

f/16

f/11

f/8.0

f/5.6

f/4.0

f/2.8

LARGE APERTURE MORE LIGHT

BACKGROUND AND SUBJECT IN FOCUS

FOREGROUND IN FOCUS, BACKGROUND BLURRY

To bring the discussion about DOF and aperture together I point to the diagram at right to illustrate how one affects the other. Aperture is determined by the settings of the blades inside your camera's lens. If you select a small aperture for creative reasons (you're looking for a shallow DOF), you are letting in a lot of light (relatively speaking) and this brings us to the next point on the exposure triangle.

SHUTTER SPEED

Simplified, shutter speed is the speed at which the shutter of your camera opens and closes. Think of it as how fast or how slowly you blink your eyes. A very fast shutter speed allows less light to reach your camera sensor, while a slower shutter speed allows incrementally more light in. Simple, right?

Here's where it gets slightly more complicated. You may think that if you're photographing in low light that you'll just use a longer shutter to let in more light, and you'd be right, but you'd also be recording more movement. There are three types of blur that occur in photography, and two of them are related to shutter speed.

The first is motion blur. Motion blur occurs when the subject's movement is recorded because the shutter remained open long enough to capture it. The second type of blur is camera shake. Camera shake occurs when the shutter remains open so long that the photographer can't hold the camera steady while the picture is being recorded. They often occur at the same time. The last type of blur is created when your lens is not properly focused. I bring up blur because there is one more way you can manipulate the amount of light that your camera allows in: ISO.

MOVEMENT RECORDED

CAMERA SHAKE

LENS NOT FOCUSED PROPERLY

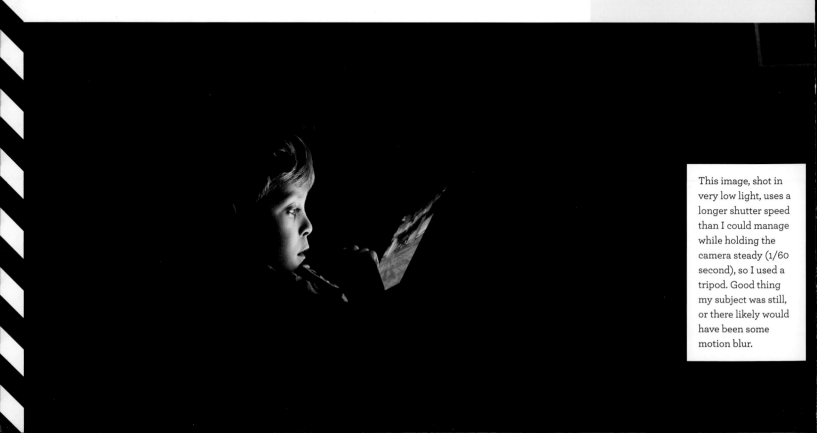

This image, shot in very low light, uses a longer shutter speed than I could manage while holding the camera steady (1/60 second), so I used a tripod. Good thing my subject was still, or there likely would have been some motion blur.

ISO

ISO refers to the light-sensitivity level of your camera's sensor. The lower the ISO (some digital cameras have an ISO setting as low as 64), the lower the sensitivity; the higher the ISO, the higher the sensitivity. You might wonder why you wouldn't always just leave your camera set to the highest ISO it allows and record the most light possible. The answer to this has to do with what happens to images taken at higher ISO settings; they take on a grainy quality that we call noise.

In the image at bottom right, I set the camera to ISO 4000. When zoomed in, you can see a pattern of fuzzy dots. I shot the image at bottom left at ISO 200, and you can see that the image appears a lot smoother.

With that, our discussion of the exposure triangle comes to a tentative close. I'll come back to it repeatedly throughout the rest of the book. For now it's only important to have a general understanding of the terms and know that they exist, and that selecting a value for any one will affect the other two.

LOW ISO, LESS NOISE, SMOOTHER IMAGE

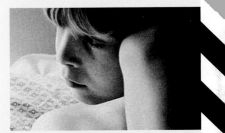

HIGH ISO, MORE NISE, GRAINIER IMAGE

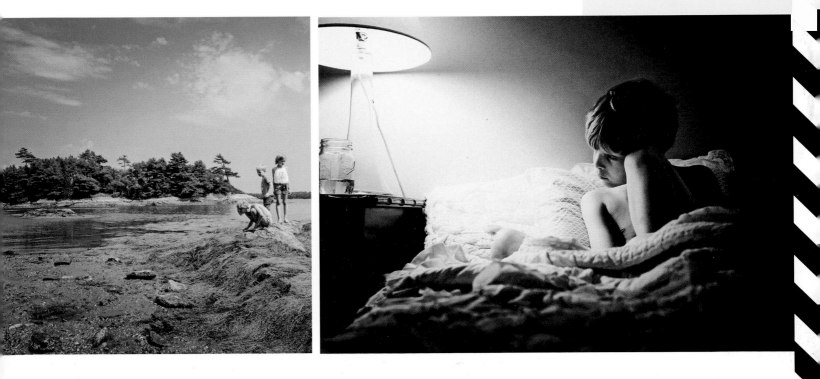

BASIC CREATIVE PRINCIPLES

NOT UNLIKE THE EXPOSURE TRIANGLE, the creative elements of a strong photograph work together and rely upon each other for a satisfying finished product. Unlike the scientific parts of photography though, the creative ones are more elusive and subjective. Even so, there are some starting points that are helpful to understand.

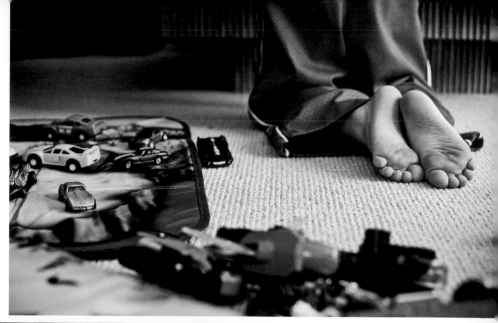

COMPOSITION

The composition of an image refers to how the elements in your photograph are arranged. There is no one correct way to compose an image and if five different photographers stand in exactly the same location with the same scene before them, they will almost certainly compose five distinctly different images. There are, however, some basic guidelines that can help you get started.

Composing an image thoughtfully and paying attention to all of the elements in your frame can mean the difference between an everyday snapshot and one worthy of a frame and a spot on your picture wall. There are guidelines and rules that you can learn to help you compose your picture, but in the end it'll be up to you to decide which or whether to employ certain techniques.

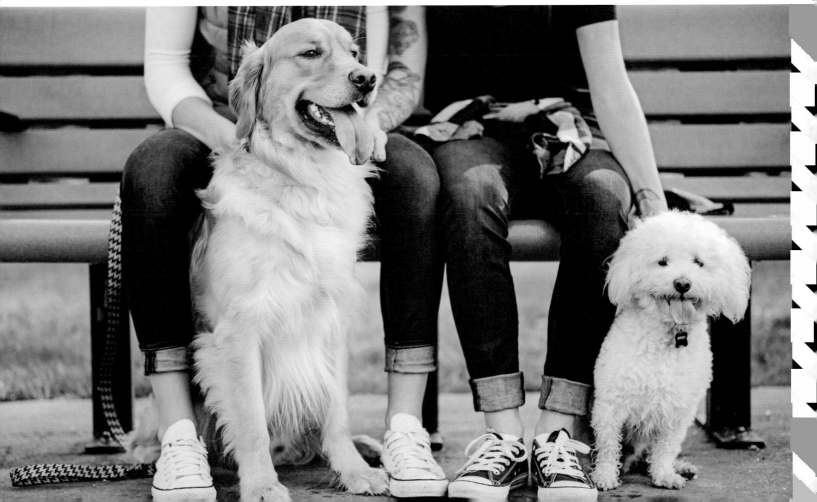

RULE OF THIRDS

The Rule of Thirds is often considered the foundation for all other compositional techniques. While it's called a rule, it certainly doesn't mean that you must follow it or that if you don't, your images will be unbalanced. It is simply a helpful technique to work with when you're not sure how to put your image together.

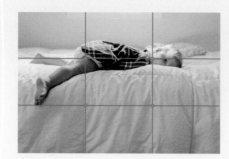

WHAT IS THE RULE OF THIRDS?

The basic idea behind the Rule of Thirds is that your frame should be divided into three equal segments both horizontally and vertically so that you have nine total segments (see diagram left). Keeping this grid in mind, you would then place the most important elements of your image on one of the lines or on one of the points where the lines intersect. The viewer's eye will naturally be drawn to those points, creating a compelling composition.

This picture is composed using the rule of thirds. Notice how the bottom third of the image is essentially blank (negative space), and your eye is naturally drawn to his face.

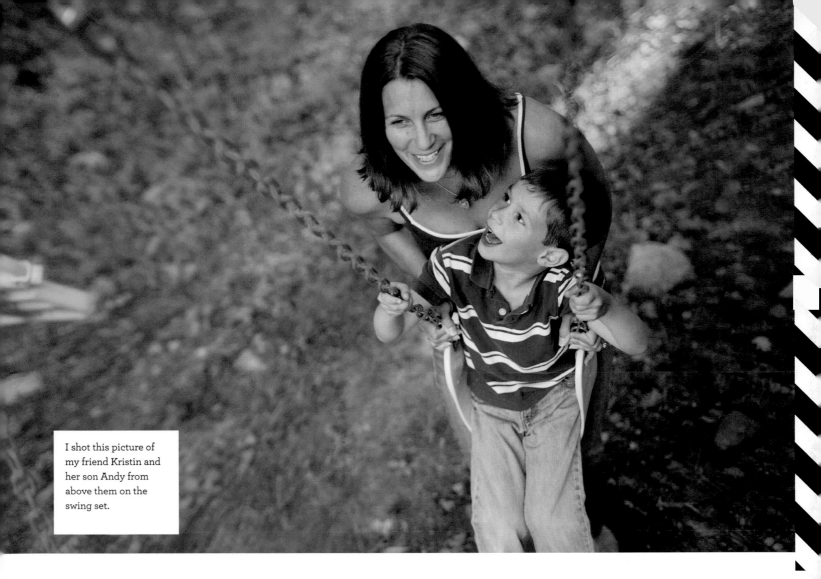

I shot this picture of my friend Kristin and her son Andy from above them on the swing set.

PERSPECTIVE

When you're composing your image, one thing to think about is where you are in relation to your subject. Changing your point of view can entirely change an image. When you're looking through your viewfinder after you've composed your image, take a step to your right or left and notice how the image changes.

Consider your height; are you at eye level with your subject or looking down at them? Photographing from below your subject will create a feeling of height. Conversely, photographing from above them will make them appear smaller. I encourage you to experiment with perspective to see how it changes your pictures.

COMPOSITIONAL TECHNIQUES

Negative space, leading lines, and framing: These are all compositional techniques that can be used in conjunction with each other or on their own to help you compose your image.

NEGATIVE SPACE

Negative space is created by placing your main subject in one area of the frame, while the rest of the frame remains virtually empty. This technique often makes for very dramatic compositions.

This photograph of my son reading in bed (shot with my camera phone) uses both the Rule of Thirds and plenty of negative space to help make a very quiet moment into a dynamic photograph.

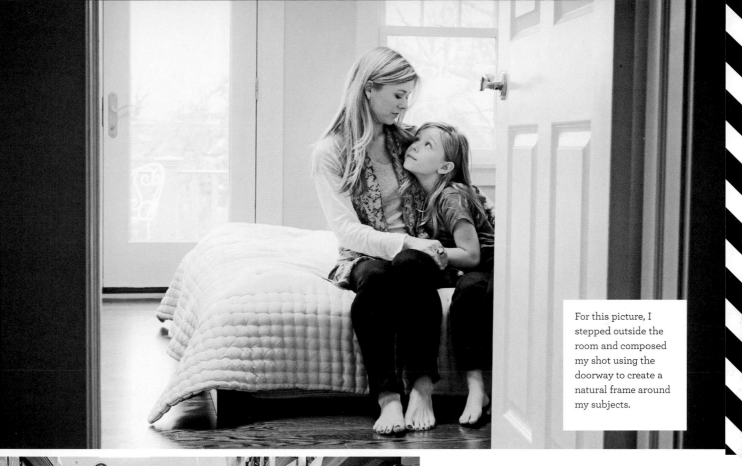

For this picture, I stepped outside the room and composed my shot using the doorway to create a natural frame around my subjects.

LEADING LINES & FRAMES

Leading lines or frames are elements in your composition, real or conceptual, which draw the viewer's eye naturally toward the main subject. When you're taking photos, looking for the leading lines or frames in your surroundings can help you ground your image. These elements can be found almost anywhere if you look for them.

Remember that whether you use any of the techniques I've described is up to you. Once you've practiced them and learned to use them effectively in your photographs, feel free to break the rules and see what you come up with.

In this photograph, the store shelves create lines that lead the viewer's eye directly to the subject—my son crouching down and intently picking out a present.

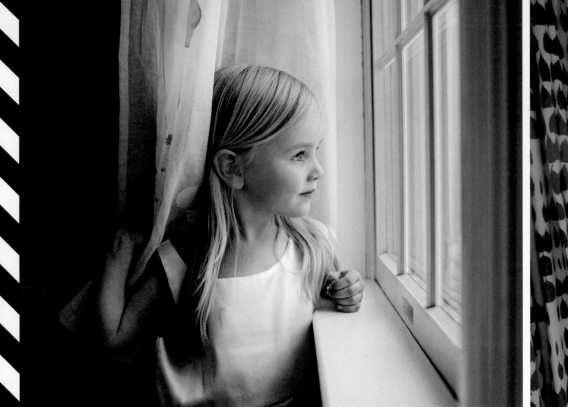

STYLE

Photographic style is like handwriting style: everyone has one, but sometimes it's hard to put your finger on exactly what it is. If you already have a distinctive photographic style, that's great. If you're just starting out, though, yours is probably developing with every photograph you take.

Most photographers I know would say that they're always refining their style. It's not something you have to define or really even fully understand beyond knowing that the way you see is unique and that your experience will color the photographs you take. Once your style starts to clarify and you see a pattern and theme in your images, embrace it! Having a style all your own is part of what will make your photographs shine.

Note the perspective in this shot. I stood above and behind my subjects, as the story I wanted to tell was in the details: hands braiding hair as the little girl does her art project.

The bright colors and movement here add to the happy mood of this picture.

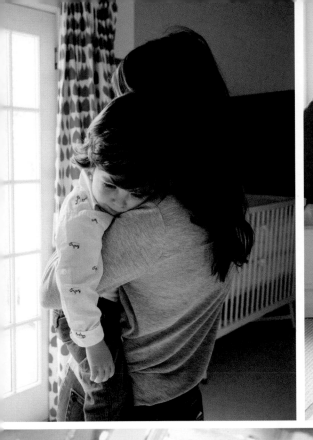

HOW TO READ A PHOTOGRAPH

One of the most important ways you will help yourself to grow as a photographer is to look at lots of pictures. Look at your own pictures and look at pictures that others have taken. Begin to decipher the parts of these pictures shown here. How are they composed? Where is the light coming from and how is it affecting any shadows in the photograph? What perspective was the photographer using? What is the story behind the image? Do you like it? These questions will get you thinking like a photographer and you'll help your own photography along by stretching these muscles.

A CONVERSATION ABOUT CAMERA CHOICES

IF YOU'VE SKIPPED AHEAD to this section because you're wondering how much of your savings you're going to have to blow on a camera, you might be pleased to find out that a fancy camera isn't a requirement for wonderful photographs. That's not to say that more advanced equipment won't help you—it will. (My favorite analogy is the chef who has really sharp knives and a double oven: You can cut the veggies with any knife and you can cook your casseroles in shifts, but your job is a whole lot easier if the knives are ergonomic and perfectly honed, and you're more productive if you can cook both casseroles at the same time.)

Let's start with the basics. You probably already have a camera: your phone. I love my camera phone. I use it all the time and many of the images in this book were shot with it. You can't do everything with a camera phone (don't bother with the zoom feature, and if you're photographing action, you're likely to miss something), but where it shines is its portability. The old adage about the best camera being the one you have with you was never so apt as with a camera phone. You can use your phone for many (but not all) of the prompts in this book.

There are many types of digital cameras on the market and more being introduced every year. If you're shopping, you'll hear terms like: DSLR, mirrorless, rangefinder, point-and-shoot, crop-sensor, full-frame, megapixel, and more. Most any type of camera will be able to achieve the looks in this book. As you grow as a photographer, you might find that you need features that your current camera doesn't have, and to me, that's the best measure of what you'll need when searching for a new camera.

GEAR TO HAVE ON HAND

- **Camera Bag:** To make this whole thing work, you need to bring your camera with you (almost) everywhere. You can absolutely use your camera phone or a small point-and-shoot camera, but if you want to use that DSLR you spent hundreds of dollars on, you have to lug it around. Invest in a bag you won't hate carrying. (See pages 140–141 for some suggestions.)

- **Extra Camera Battery:** Always keep a charged backup battery handy.

- **Camera Manual:** Find it and learn about how to make your camera do what you want it to. Keep it handy in case you want to try something new on the fly.

There are cameras at all price points and sizes to meet the needs of any photographer. The Sony a600 is a compact, mirrorless camera that allows you to interchange lenses. This type of camera is rapidly gaining favor among amateurs and professionals alike for it's superior image quality and extreme portability. The iPhone 6s/6s+ both have outstanding cameras while having the added benefit of the fact that you'll always have yours close at hand.

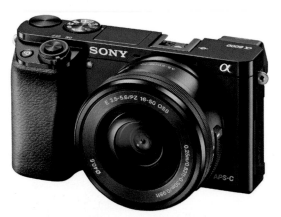

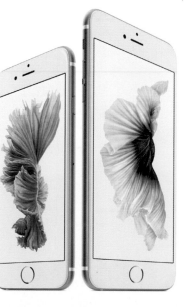

CAMERA PHONE

Whether you have a DSLR or not, chances are, you probably already have a camera phone and, if you're like me, you always have it with you. Don't discount its usefulness in capturing your family's daily life. Of course, the most advanced professional gear can produce superior technical quality, but if that were all that mattered, anyone with an expensive camera could take amazing photos. It's not all that matters. The most important part of any image is the photographer's (that's you) intent and vision.

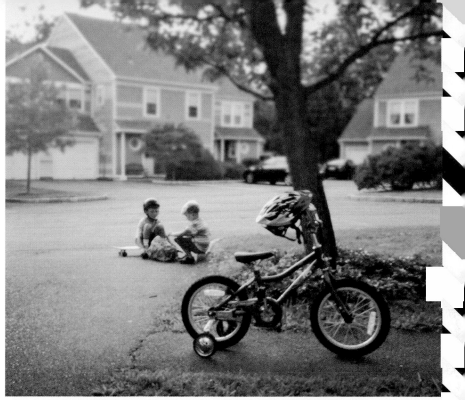

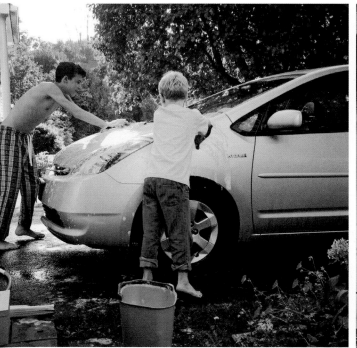

CAMERA PHONE TIPS

When photographing with a mobile device, don't forget to compose your image thoughtfully. Consider your point of view, check your lighting, and keep in mind these few mobile-phone-specific tips:

• **Know Your Limitations:** Mobile phones aren't good at everything. In low light, for example, you have to use a flash, as mobile devices don't have an ISO setting.

1. **Skip the Zoom:** To avoid losing resolution and coming away with fuzzy results, if you want your subject to be closer to you, don't use your phone's zoom feature. Instead, "zoom" with your feet—get closer! Even the most advanced mobile-device cameras fall short when they're zoomed in.

2. **Keep It Simple:** Even more than with a DSLR, when you're photographing with a phone you need to make sure your frame is free of extraneous elements. This is especially true because mobile images are most often viewed on mobile devices (which are small), and too many distracting details in the picture will overwhelm the viewer and detract from the main subject.

3. **Use Negative Space:** While I encourage you to keep all of the same compositional techniques in mind that you would if you were photographing with a DSLR, negative space works particularly well in mobile photography.

4. **Hold Steady:** Part of a phone's appeal is that it's small and light, but that also means it's a magnet for camera shake. Hold your phone like a camera, with two hands, when you're photographing.

5. **Keep Photographing:** Don't be afraid to take a whole bunch of frames of the same image. Most mobile phones can take photos in burst mode. Learn how yours works and use it. Later, when you're reviewing your pictures, don't forget to delete the ones you don't need to save space.

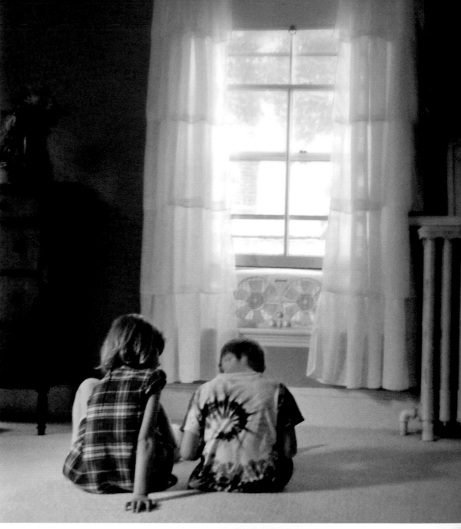

APPS

There are tons of great apps out there. Taking the additional time to edit your pictures with any of them can take your camera phone pictures to a whole new level. Play around with effects and filters to see how they can enhance your pictures. My two (current) favorites are: Snapseed for editing and Instagram for online sharing.

SOFTWARE & POST-PROCESSING

IT'S HELPFUL TO KNOW what you will need after you've taken your photographs to make them look their best. Here is a short list of what post-processing tools you'll want to have handy:

COMPUTER

Most any computer will do nowadays. How powerful a computer you need has everything to do with how much post processing (photo editing) you decide to do.

IMAGE-PROCESSING SOFTWARE

There are two main types of software: organizational and editing. Organizational software is more or less a requirement if you plan on taking a lot of photographs (and I suggest you do). You'll need a way to catalog and organize them. Most organization software has built-in features that allow you to do basic editing right in the program. Software in this category includes Photos (Apple's proprietary program) and Adobe Lightroom. Photos comes free with Apple computers and is sufficient until your photographs number in the tens of thousands, at which point Lightroom becomes a better choice.

As for editing software, it's not a requirement (especially if your organization software can do basic editing tasks), but should you decide you want to learn more complex post-processing techniques, you'll need to invest in software.

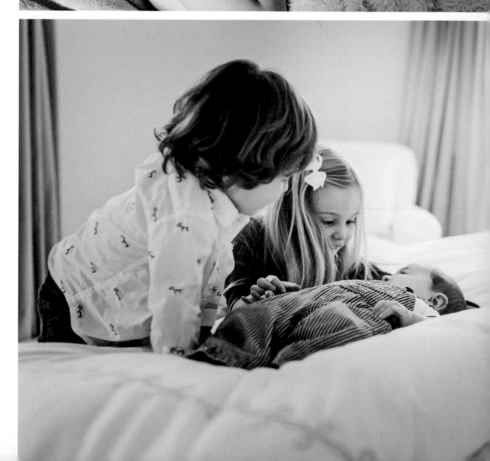

Don't risk losing your irreplaceable images by skipping (or forgetting) the crucial step of backing up.

PHOTOSHOP

Photoshop is the gold standard. Adobe offers an abridged version of the program called Photoshop Elements. It is substantially less expensive than the full version and has more features than most home photographers will ever need.

Lightroom is a computer program that is extremely helpful for organizing large photo libraries. It also contains powerful editing tools both for desktop and mobile platforms.

There are many cloud storage systems that can be set to back up automatically at programmed intervals when you're within Wi-Fi range. iCloud and Apple Photos work together to keep your photos safe. If one of your devices fail, the images are safe in the cloud.

A BACK-UP PLAN

The last thing you'll need is a way to store and save your photos. If you take nothing else away from this book, let it be this: back up your pictures! Computer hard drives will fail. If you're lucky, yours won't fail in the time you own your computer, but not everyone is that lucky. Nowadays, storage is inexpensive. Options include disk storage (buy an external hard drive and copy your photo files onto it) or cloud storage (use the Internet to upload your photos to a cloud-storage service). Do either, but be sure to do one.

SHARING, PRINTING, & STORING

SHARING

One of the greatest things about digital photography is how easy it is to share your photos with others. Even so, the vast landscape of online photo sharing can be overwhelming if you don't know where to start. If you already have social media accounts, you can simply start there. Sharing images on Facebook is easy and you can adjust your settings to share with specific groups or share with all of your friends. Many people aren't on Facebook though, and it doesn't function well solely as an organizational tool.

To create online photo albums with many levels of organizational capacities and robust privacy and sharing features, use a service like Flickr. Flickr is free for a large amount of storage and you can even use it as a backup system (see page 37). You can create photo albums that are completely private or share them with specific people. No one has to have an account to view your images and sharing links to particular images or albums is very simple. There are other online services that offer similar functionality with varying levels of storage capacity and different features (see Resources on pages 140–141). And don't forget to get your favorite images out of cyberspace and off your hard drive by printing and sharing!

Now that you've taken all of those wonderful pictures, don't risk them falling into hard-drive purgatory (that deep dark place inside the digital world). Enjoy them in real life by having them printed or printing them yourself. There is something very powerful about holding a printed photograph in your hands. Make a scrapbook or a photo album, or use them to decorate your world by framing them or using your own creative flair to display them.

PRINTING

How many times have you heard yourself or someone you know say, "I have ten thousand photographs of my children, but they're all sitting on my hard drive," or, "I'd love to print my photographs, but I don't know where to start!" One of the major differences between the days of film and digital photography is, quite simply, photo albums. It used to be that the only thing to do with your images was print them. Even if they were all just stored in a box in a closet, you at least had a printed copy. Today, it's so easy to photograph and store, and photograph some more that many of us have no printed copies of our images.

I encourage you to make printing part of your workflow. Take photos, save, print, and store. Do it as often as it works for you. I print books at the end of every calendar year. I consider it the end result of my documentary assignment. All year long as I upload and save my images, I put my favorite ones in a special folder. At the end of the year, I go through the folder and browse all of the other images from the year and I print a book. There are various online services that will do this for you at all different kinds of price points, and you don't need any special skills to do it. You may opt to print photos instead (using an online printing service is cheap and easy) and scrapbook them or frame them or do all of the above. Just please don't let them languish on your hard drive in perpetuity.

STORING

With digital photography, storing is easier and takes up less physical space than the days of film negatives, but it's also almost invisible and easy to forget to do. As I said in the Software and Post Processing section (page 36), the most important thing you can do is back up your photos. Computer hard drives can and do fail. The only question is, will yours fail while your photos are stored on it? Back up your files! Make copies of every photo you take by storing them in multiple locations.

Before digital photography, the only backups were negatives and they had to be kept safe from harm in moisture- and light-proof containers. These days, there are much easier ways to protect images that were created digitally. The method you select for storing will depend on your needs and budget. The main options available to you are cloud storage and external hard drive.

External hard drives range from very small to moderate-sized box-like devices that either sit on your desk or travel with you (they are portable). To use one of these, just hook it up to your computer with the cord that comes with the device and either drag and drop or use backup software to get your files on to it.

Some external hard drives have a wireless option and can be setup to backup automatically at regular intervals. The main advantage of external hard drives is that

you don't need an Internet connection to access your device. The main disadvantage to them is that they too are susceptible to failure. In addition, they can be damaged by water, fire, theft, etc.

Cloud backup works more or less the same way except you don't purchase an actual hard drive. Instead, you essentially rent space on a secure drive "in the cloud" and your files must be delivered through the Internet. Many companies provide this service, making it relatively affordable and very secure. The downside, of course, is that you must have access to the Internet to upload and/or restore your files. Whichever storage method you select, I recommend backing up all of your original files either every time you upload to your computer or at the very least at regular intervals (once a week, month, etc.), depending upon how many pictures you're taking.

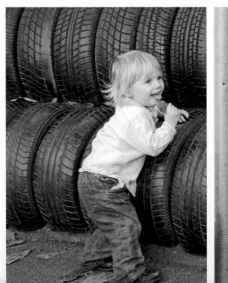

THROW THINGS OUT

Now that I've convinced you to back everything up, I also want to encourage you to also throw things out. Just take a moment as you look through your images and toss the ones that you don't need. You know the ones: eyes closed, your child picking his nose, etc. This is especially necessary if you've been photographing in "burst" mode. You don't need 20 frames of the same image. This one simple step saves storage space and will make sorting through your images later on much less arduous.

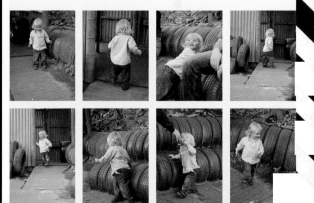

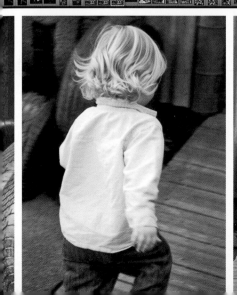

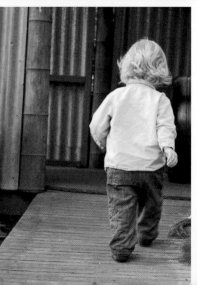

When you shoot in Burst mode on your camera and you end up with more pictures that you really need, be sure to weed out the ones that you definitely don't want to keep.

BABIES

"Where does the time go?" It's a question you'll hear a hundred times before your baby's tenth birthday and wonder to yourself a thousand more before she leaves for college. This **sentiment is never so true** as it is when it comes to newborns. It's normal for a baby to triple his or her birth weight in **the first 12 months** of life. **Children never grow that fast** or change so much in such a short time again, so the first piece of advice I always give new parents is: **Don't wait to start taking pictures**. It's so tempting to assume there will be plenty of time later. After all, you're so tired you can hardly **pick up your camera**. The following are some suggestions about how to immortalize those **sleepy, squishy moments** that will be gone before you blink.

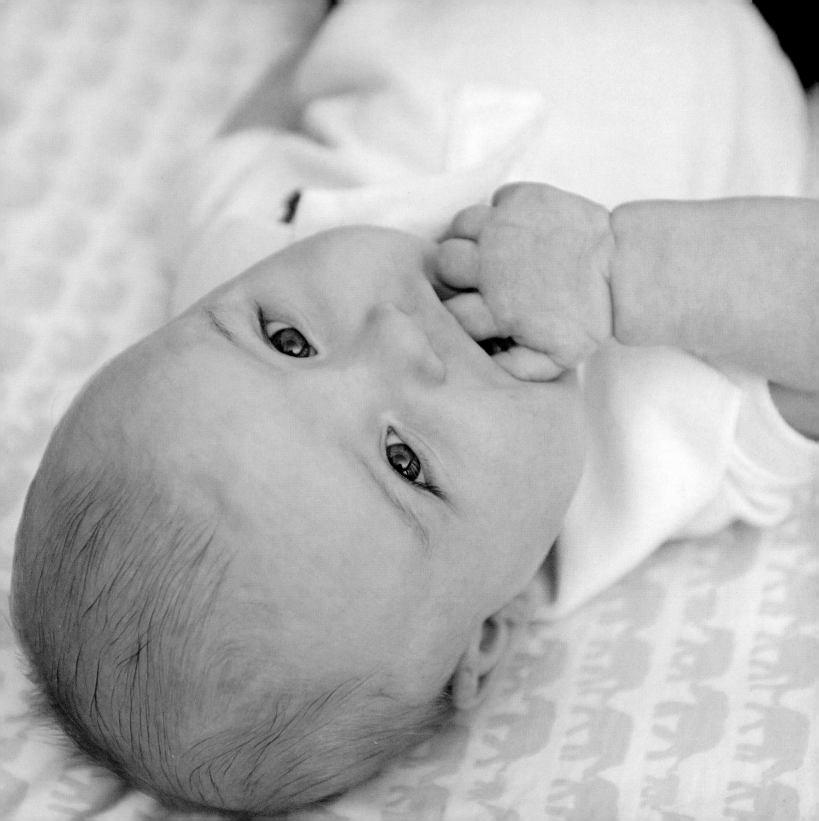

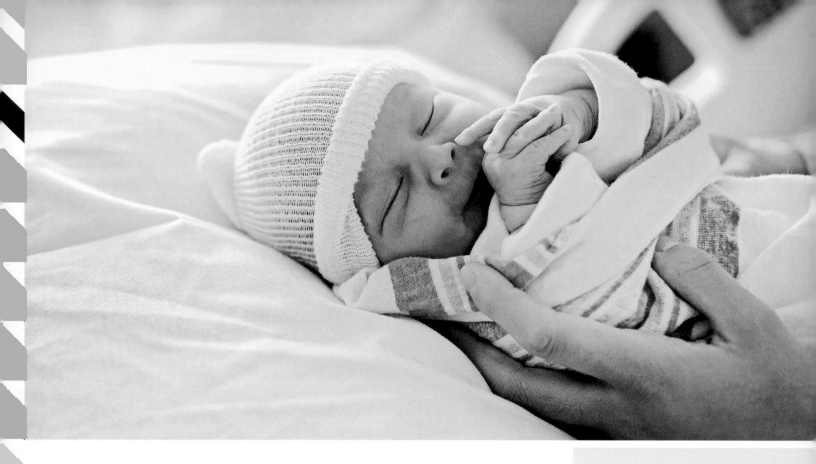

THE FIRST 48

THE FIRST 48 HOURS are a whirlwind of exhaustion and excitement. There is no question that meeting your baby for the fist time is life changing. When packing for the hospital or preparing for a home birth, most people probably aren't thinking about their cameras. Of course, your phone will do the trick for a snapshot, but this is one of those times when bringing "the big camera" will prove worth it.

Of course your hair is a mess and your eyes are puffy—you just had a baby! However, I guarantee that when your new baby is leaving for college and you find this photograph, none of that will matter. When you're up and around a little, be sure to take the camera back and immortalize Dad's expression as he becomes acquainted with his new baby.

TIP

Have your camera set when you pack it. Format the memory card, charge the battery and, if you have one, pack the flash (remembering that your flash needs fresh batteries, too). Put your camera in the Auto mode and give your partner or birth attendant a quick lesson in how to operate it. Having all this set before you leave means less tweaking to do in the heat of the moment.

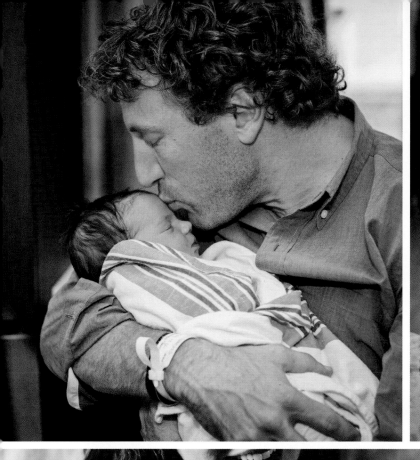

Capture the moment that bigger siblings are introduced to the new family addition.

Have a nurse or birth attendant photograph those first moments meeting your baby.

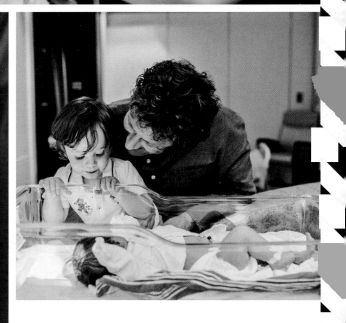

EARLY DAYS

DETAILS ARE NEVER so dramatic as they are in the first months of your baby's life. Tiny toes and fingers, lips and ears—even bottoms—all make for adorable and striking photographs. To best capture newborn details, zoom in close and don't be afraid to fill the entire frame with your subject.

To immortalize those tiny parts in striking images, position yourself so that your frame is filled with your chosen detail. Or incorporate some color by including a family heirloom, like this sweet pink quilt, by pulling back a bit.

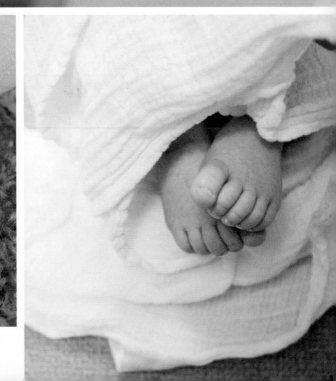

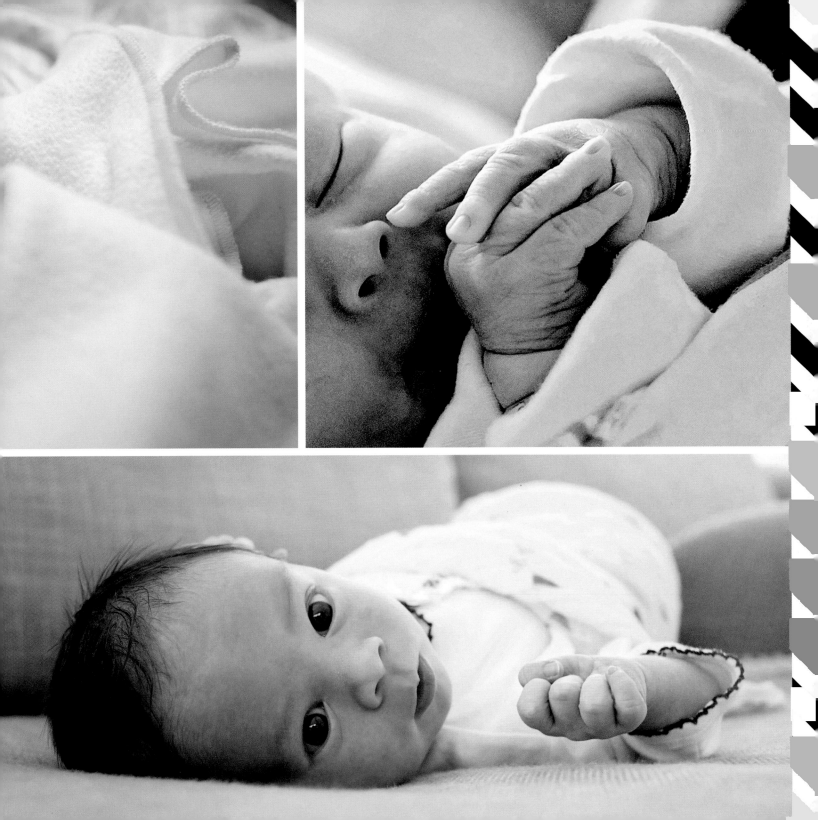

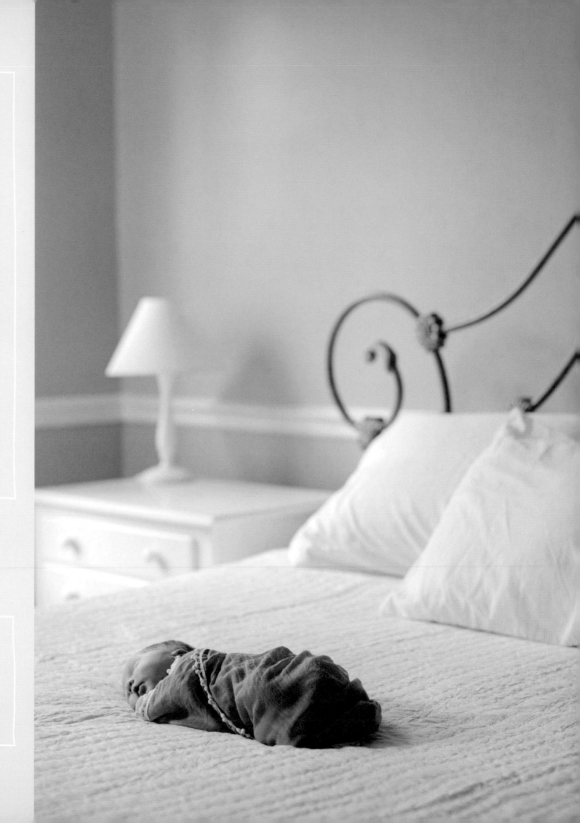

SAFETY FIRST

When taking any photographs of babies or children, you must always put safety first, but with small babies especially, I can't emphasize that enough. Those adorable images you've seen on Facebook of tiny babies sleeping on swings in the middle of the woods? They were photographed by professionals. The baby was never unattended, and a spotter had a hand on the baby at all times. The final images are composites created by using multiple frames and Photoshop magic. If you're placing your child on a bed or other raised surface, please be sure that they are secure and there is no way for them to roll and fall off. (Having another person nearby, just out of the frame can be helpful.) No photograph is worth any measure of risk to a child.

TIP

When standing above your subject, always wear your camera's neck strap just in case you lose your grip!

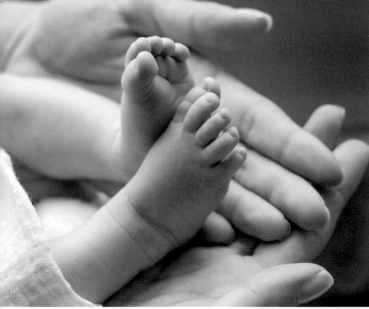

SCALE

Your newborn is the tiniest human you've ever known yet—alone in a photograph, it's difficult to tell just how small this little person is! For scale, don't forget to photograph baby in Daddy's arms, or snuggling Mommy. Placing a favorite stuffed toy in the photograph next to the baby or showing a parent's hand in the frame can also work well.

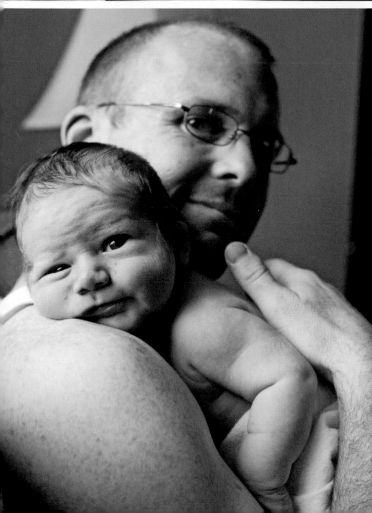

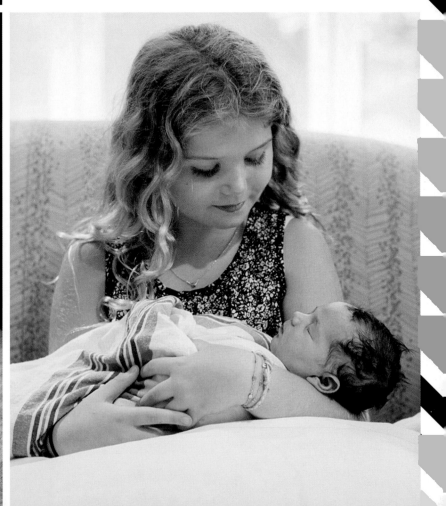

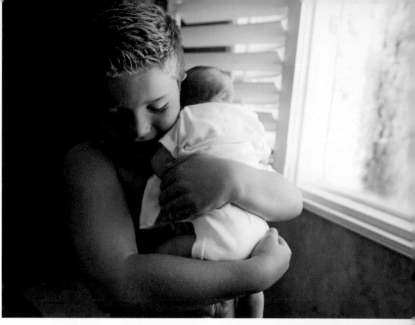

LIGHT

To make the best possible images, watch the light. If there's one thing I'll repeat over and over in this book, it's that. Even the most poignant moment captured won't be worth framing or sharing if your exposure is so far off that you can't see the details or expressions. Don't be afraid to move the cradle over by the window to utilize that soft, indirect light. All of these images were taken using light filtering through a nearby window, with no flash. If necessary, move the baby to the light instead of taking the picture under unflattering or harsh lighting conditions.

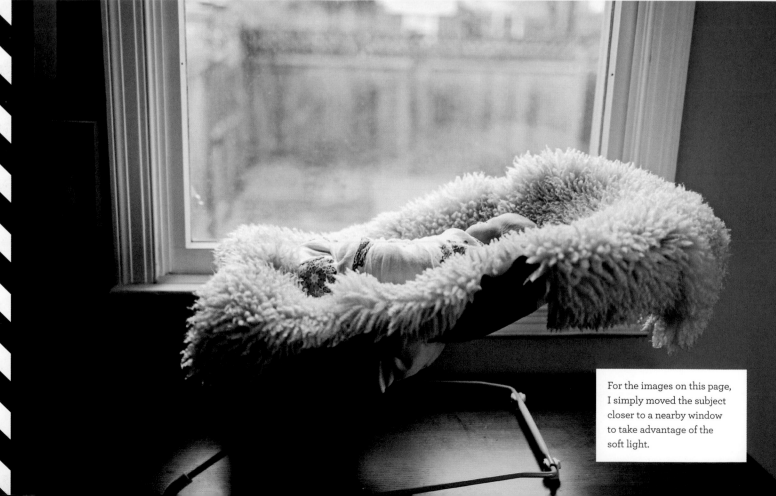

For the images on this page, I simply moved the subject closer to a nearby window to take advantage of the soft light.

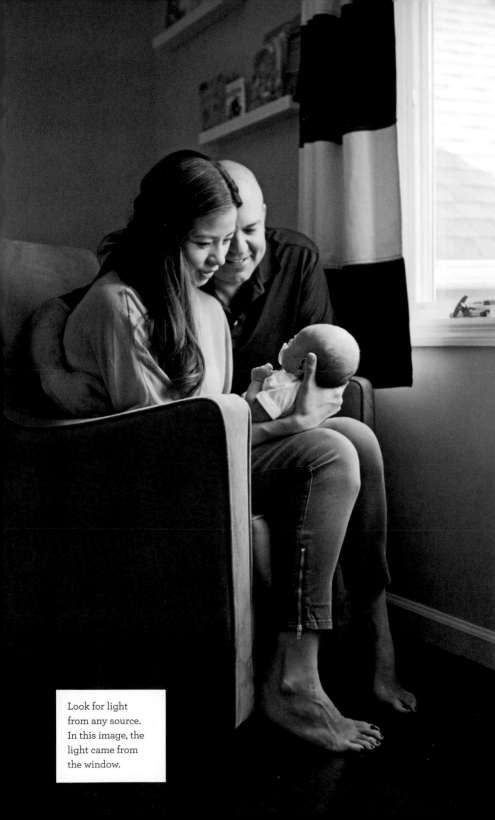

Look for light from any source. In this image, the light came from the window.

LOW-LIGHT TIPS

Good lighting is a crucial component in great photographs, but this is a book about real life! In real, day-to-day life there won't always be good light when you want to take a picture, so here are a few ways to help make the most of whatever light happens to be around when the moment strikes:

- **Use whatever light is available.** Just because it's dark doesn't mean there isn't any light.

- **Learn to see where the available light** is and make the most of it.

- **Move it closer to your subject** whenever possible or add more light to the scene if you can, even if it's just a lamp or some candles.

- **Take control of your camera.** If you're shooting with a point and shoot, try setting it to Night Portrait mode. With a DSLR you'll have more control; bump your ISO up. Remember, the higher the ISO, the more noise or grain you'll have in your photograph.

- **Embrace the grain.** When shooting in low light and using a high ISO, your images will be grainer. Go with it! Try converting your photograph to black and white with post-processing software (see page 36). Low-light black-and-white images often have more contrast and tend to be more forgiving than their color counterparts.

- **Turn off your flash:** It might seem counterintuitive, but your camera's flash will often cast very harsh shadows on your subject and overexpose the lighter parts of your image, leaving you with a washed-out subject.

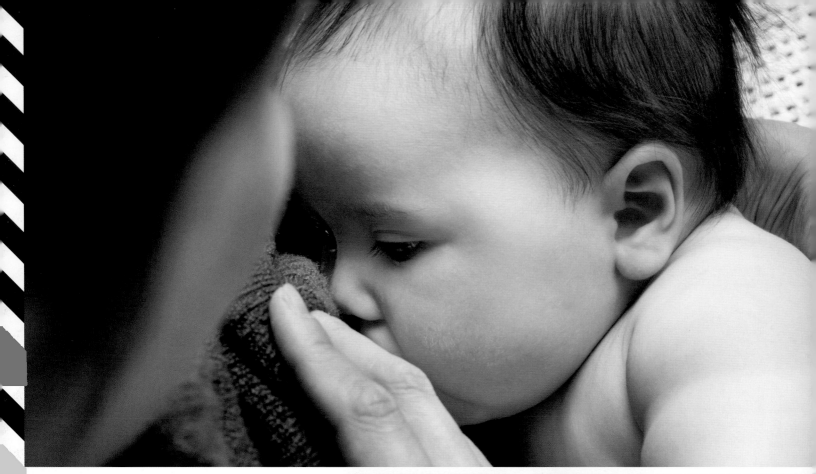

FEEDING TIME

FEEDING TIME WITH BABIES runs the
gamut from peaceful and connected to messy
and hysterical. My memories are hazy, but
looking through the pictures I have transports
me back to the early sleepy days of nursing my
babies until we both fell asleep. I'm so grateful
for the few images I allowed my partner to
take. If you're not comfortable with nursing
photographs, consider changing your
perspective to capture the mood and
subject without sacrificing modesty.

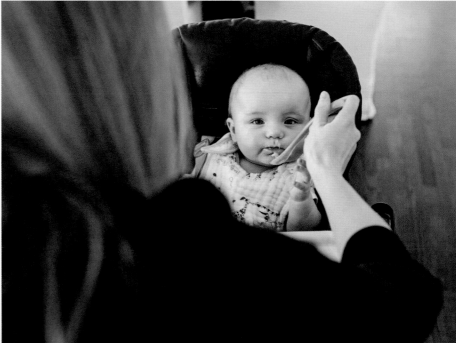

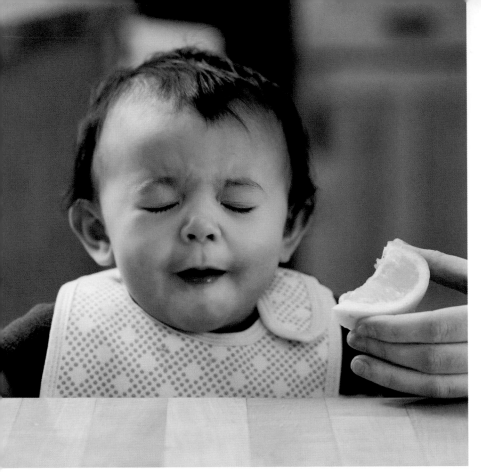

As babies get bigger, they're likely to spend a lot of time in a highchair. If possible, place the highchair so that it is facing a window so that when the cute stuff happens, you've got light on your side. If natural light isn't an option in your feeding area, here are a couple of suggestions for capturing the look on the baby's face the first time she eats chocolate ice cream (or pizza, or a lemon!):

• **Move It:** Just move your feeding area into the light temporarily. The pictures won't be any less adorable because they weren't really taken in the spot where baby usually eats.

• **Increase ISO:** Bump your ISO as high as you need to so that you can easily photograph in the available light. Today's digital cameras handle high ISO situations better than ever before and you can even reduce much of any noise that does result with a photo-editing software program after the fact (see page 36).

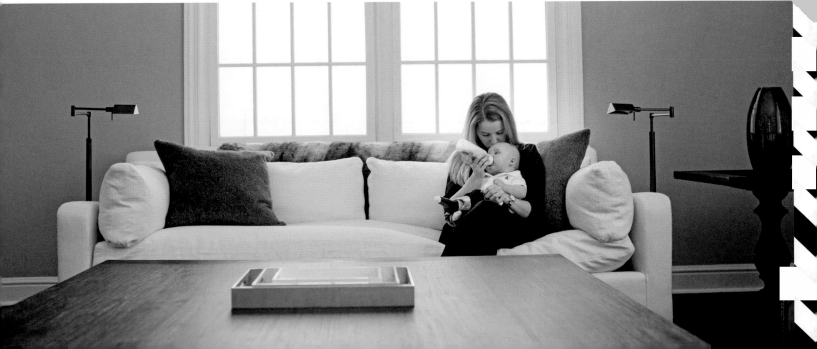

Break away from the idea that your subject has to be looking straight at the camera.

SITTING UP

ONE OF MY FAVORITE STAGES to photograph is the brief time in between when babies start sitting up on their own and before they are crawling (or running) away. It's typically pretty easy to capture their attention and they'll often play for long periods of time in one spot. Put their favorite toys in a well-lit area, keeping in mind that the best light will be in front of, or to the side of them. Light that shines from behind your subject can be tricky because the subject's own shadow falls on them, putting them in a silhouette.

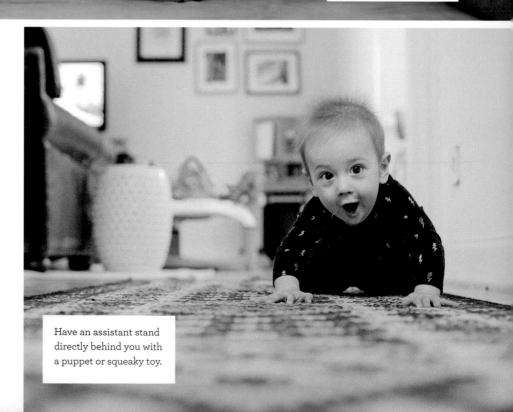

Have an assistant stand directly behind you with a puppet or squeaky toy.

CRAWLING

IN EVERY "TIPS AND TRICKS" article ever published about how to take better pictures of your kids, getting down on their level pretty much always tops the list—and for good reason. Photographing your subject at eye level helps to form a connection between the viewer and your image. It also creates a natural perspective, especially when baby is crawling around. Get down low and see things from their perspective. And after you've gotten down on baby's level, go ahead and break that "rule" and mix it up. Photographing from above a baby amplifies how tiny they are.

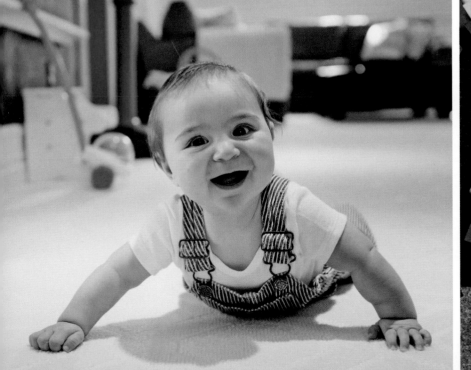

This picture, taken from above, gives the viewer a real feeling of how quickly baby is scooting around. He can't even stay in the frame!

BATH TIME

WHAT'S CUTER THAN A naked baby? Bath time is one of those activities that will happen a million times throughout the first few years. From sponge baths in the portable tub, to sitting up in the kitchen sink, to bath toys in the big tub, bath time is filled with quintessential baby-picture moments.

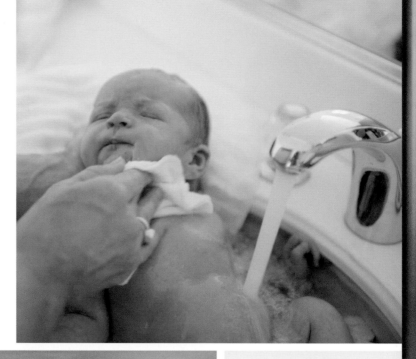

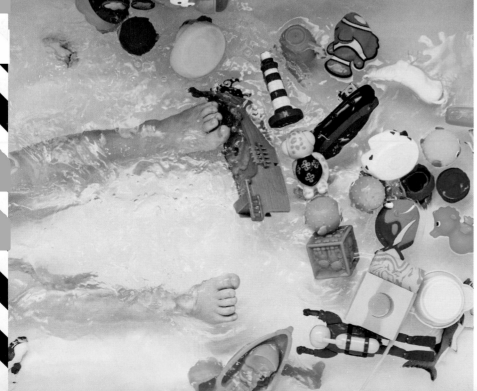

TIP

Never leave baby unattended when you're taking a picture. Have your camera ready before you put him or her in the tub and if baby is not safe sitting on their own, make sure you have an assistant when you step back to take the picture.

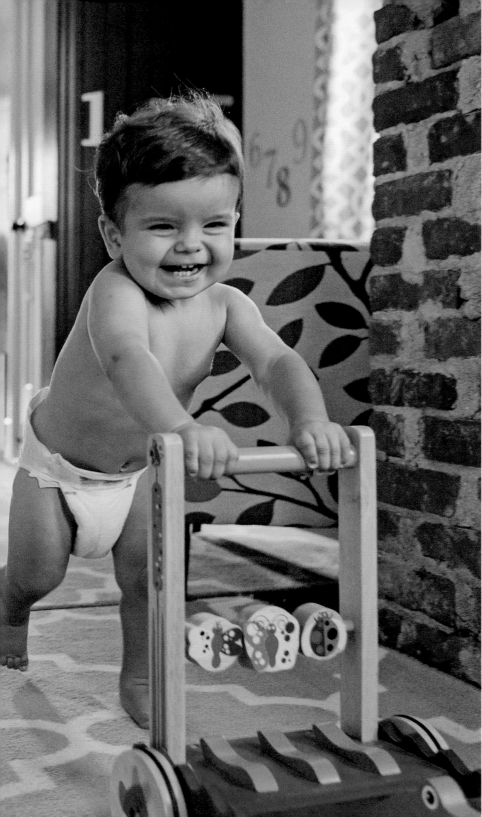

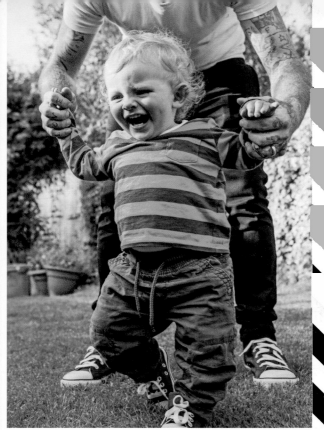

FIRST STEPS

IN THE FIRST YEAR ALONE, there will be so many milestones that your head will spin. Don't stress yourself out about capturing them all exactly as they occur. A photo of one of the first times is just as memorable as the very first time. If you miss the first steps, don't fret. You can capture the twentieth and it'll still be amazing to look back on. When he starts to walk, be sure to get down on his level (don't be afraid to actually lay on the ground and use your elbows to prop yourself up) and capture some of his facial expressions as he realizes what he's doing.

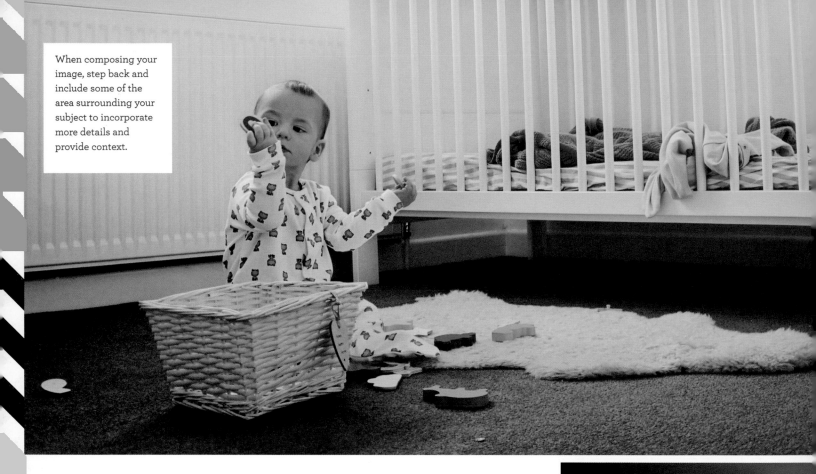

When composing your image, step back and include some of the area surrounding your subject to incorporate more details and provide context.

PLAY TIME

PLAY IS A TODDLER'S full-time job. It's their way to learn and make sense of their world. Everything is fair game when it comes to play, and photo opportunities abound. As with every other photograph you'll ever take, there are numerous factors that go into making a memorable image. If there is any one factor that can make or break your picture though (I told you I'd repeat this throughout the whole book), it's the light. You might have the exact perfect moment or just the absolute most adorable expression, but if there isn't enough light to illuminate your subject—or there's too much light and your subject ends up in shadow—the image will be spoiled.

PRIORITIZING LIGHT

There are different ways to deal with light in your images. In some situations, you'll be unprepared. Something cute will happen and you'll find yourself reaching for your camera or phone. In these moments, let your camera do the work. Take your picture in Auto mode, get what you get, and consider it a win if you have a picture that will remind you of that moment—let's call it a snapshot. In other situations, you'll have the time to set up the scene under the perfect conditions. At these times, you're more likely to have the inclination to put your camera knowledge to work. With a semi-stationary subject (say, a child playing with blocks on the floor), I might switch to my camera's Aperture-Priority mode and experiment with a shallow depth of field.

In these images, only a small sliver of the photos is in focus, which really draws the viewer's eye to the subject.

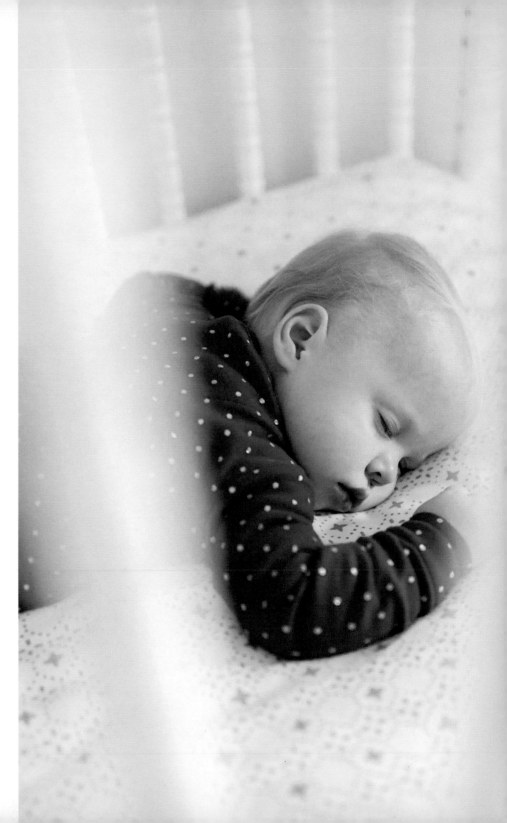

SLEEP TIME

EVERY PARENT I KNOW has confessed to me that they've spent hours watching their child sleep. Photographing sleeping babies is a no brainer; they're not moving and they're adorable! Photograph them at different ages in their crib to document the rapid growth in the early days. Photograph them as they sleep in a parent's arms or in the swing as they couldn't fight off sleep for another minute.

Photographing daytime naps is easiest because there will be more light to work with. Don't be afraid to move things around (before baby falls asleep) to take advantage of the best light, but remember to look for soft—not harsh—light. Filtered light through sheer curtains or indirect sunlight through a window will work better than direct sunlight.

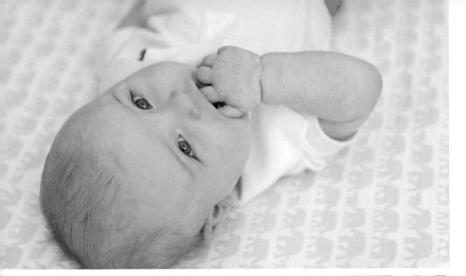

If there isn't enough light, avoid startling baby by using your flash and instead try bumping your ISO to the high end and see if that gives you some latitude. You can also opt to put your camera on a tripod and shoot with a longer shutter speed since you're photographing a stationary subject.

Use the crib or other surrounding elements to create a natural frame for your main subject. Here the mobile, crib and stuffed toys work together to create a dynamic composition.

KIDS

From the **first days of school** to lost front teeth, baseball practices, dance recitals, training wheels and beyond, childhood is **one big photo opportunity**. All of the **adorable firsts** and important milestones deserve documentation, for sure, but when I look through the images of my **children's early years**, the real **story unfolds** in the moments in between. **A child's hobbies** and **friendships**, the things that they love and the things that they struggle with, **all are pieces of their whole**.

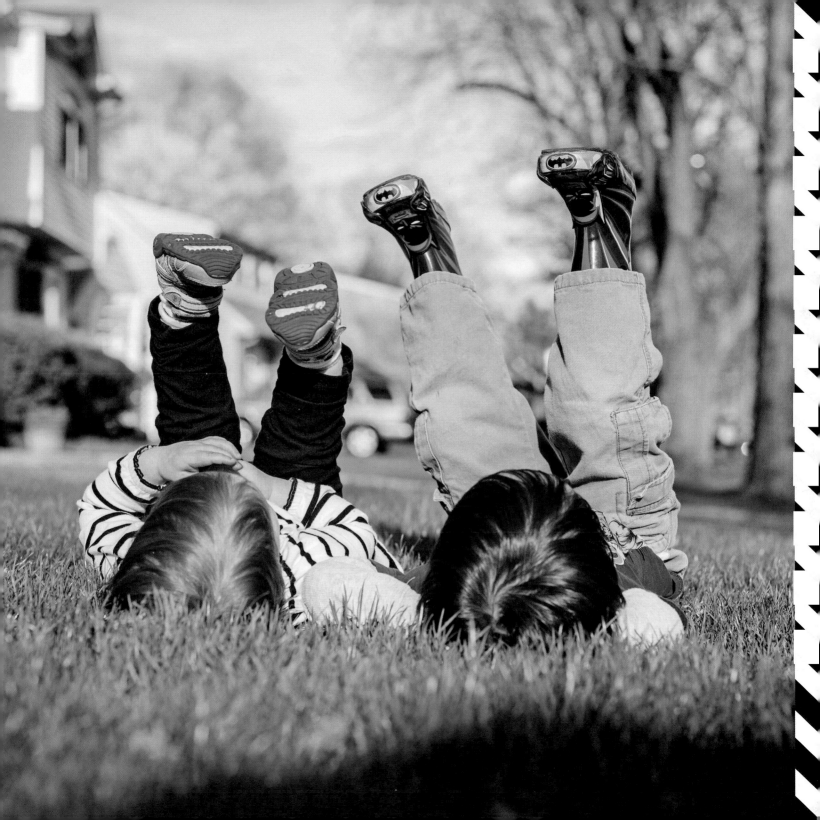

CREATIVE VISUALIZATION

PHOTOGRAPHING KIDS—both big and little—requires creativity, a little planning, and a whole lot of patience. All the basic guidelines apply:

- **Look for the light**
- **Anticipate the action**
- **Check your perspective**
- **Compose your image**

More than anything else, though, look beyond the traditional landmarks into the inner workings of your child's world.

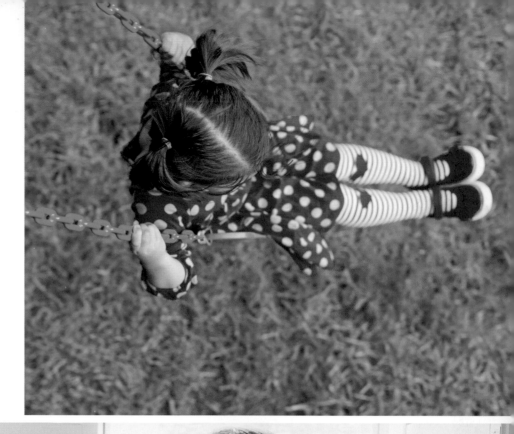

If you have children and you're waiting for the perfect moment to photograph them, you'll be waiting a long time. Consider that the messy parts of family life are often the most beautiful and be deliberate about capturing them. Look for genuine emotion of any kind and document what you see.

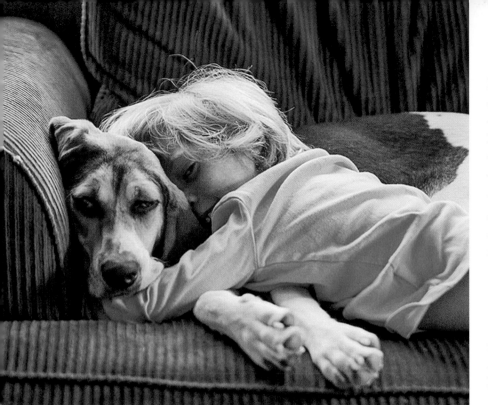

Let go of the idea that you must capture each adorable thing they do as it happens. Most children thrive on the security of routine and learn by repetition. As a photographer, you can use this to your advantage. If your child plays with trains every afternoon, you'll have plenty of opportunities to photograph him doing it. And once you've photographed it, go back and look again another day. Look at the scene in different light. Look closer at the details. Capture tiny hands putting pieces together. Get in close and capture facial expressions. Stand back far and capture an environmental shot. When you approach your photography from a documentary point of view, each moment is ripe with the possibility of a hundred different photographs.

To create visual interest, photograph from unexpected angles. Stand above the scene or peek through a crack. Sometimes parts of the subject are more dramatic than the whole. The idea is to get out of the rut of placing your subject in the center of the image and just snapping away. The variation makes for engaging images and can be the difference between a snapshot and a frame-worthy image.

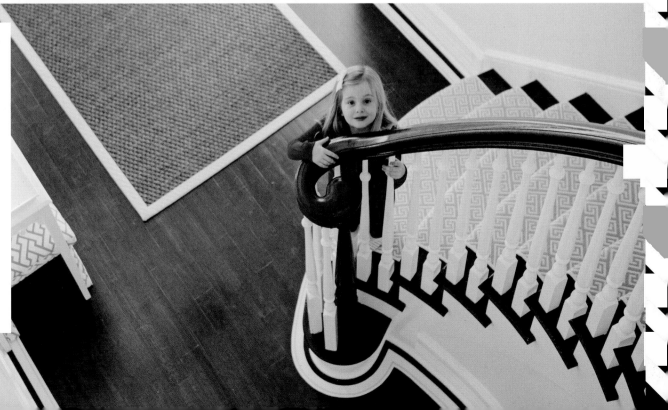

BE A STORYTELLER

Consider this as you read through the suggested images in this chapter. They're intended to get you thinking beyond "the birthday cake shot" and help you begin to see the story in the details. As you grow as a photographer, it will become more natural for you to see these moments as they unfold and be prepared to capture them in new and creative ways.

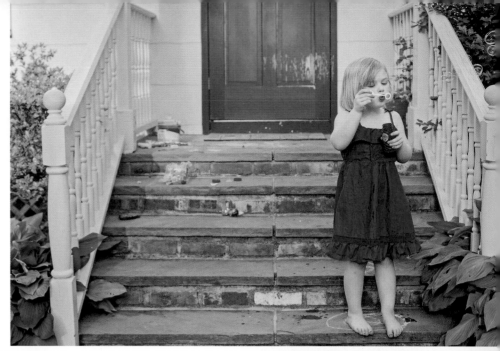

Sometimes the most poignant moment occur after the action is over (or before it even starts). Train yourself to look for in between moments where you'll often find the most genuine emotion.

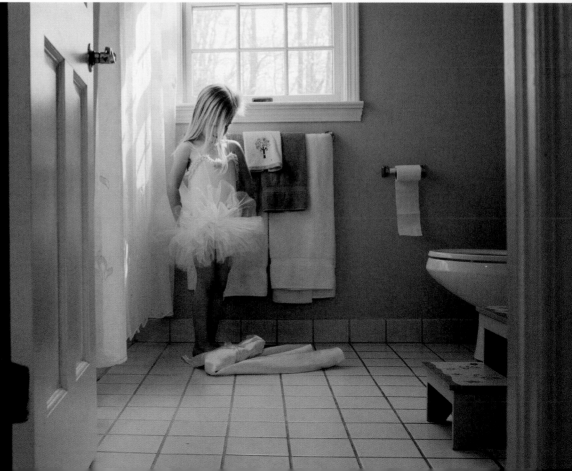

Keep the rules of composition close at hand while telling the story. A compelling image incorporates more than just an adorable subject, it must also be visually appealing.

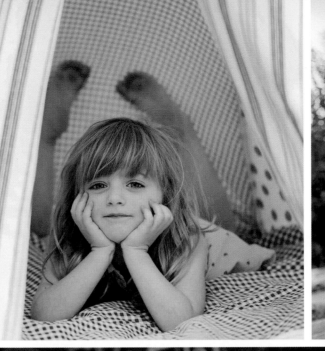

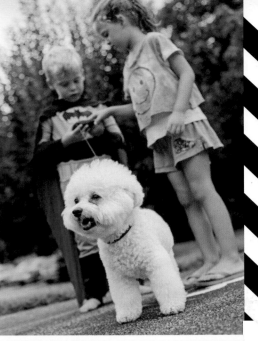

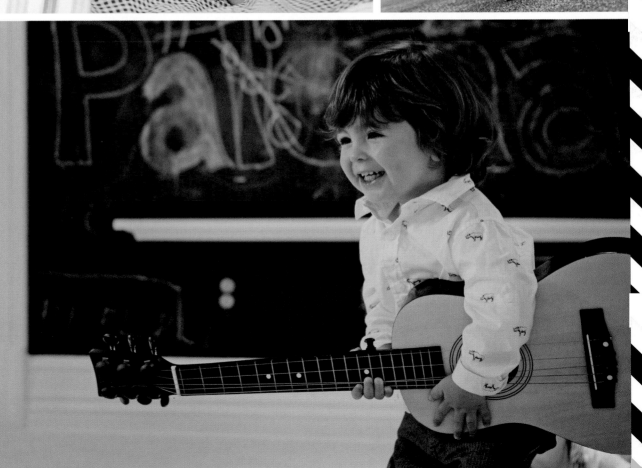

SCHEDULE A PHOTO SHOOT

IF YOU'VE GOT A CHILD who doesn't like to be photographed, try scheduling a photo shoot. Seriously, pick a time of day that your child is typically playful (i.e., after a nap or early in the morning) and remove potential distractions. Discuss it with them beforehand and make sure they're not hungry and that the light in your setting is good. Basically, make some time to take photographs and set yourself up for success. Don't ask for smiles and let go of preconceived notions about what makes a "good" photograph. You don't need a smiling face looking straight at the camera to make a memorable image.

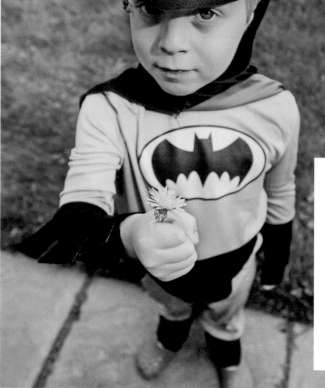

My younger son dressed as a superhero for an entire year when he was four. I never get tired of pictures I took during that time, but it helps that I changed it up and shot from different angles. For this one, I stood on a table!

There's no need to include faces in every picture. This photo tells the story of a dance party using showing only these sisters' feet.

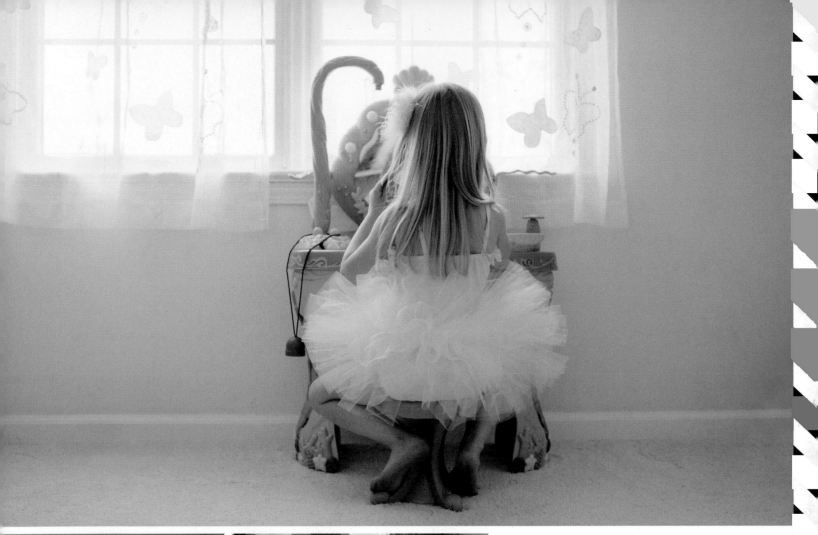

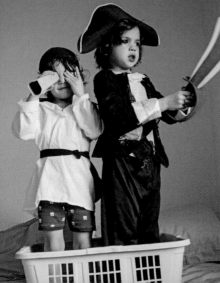

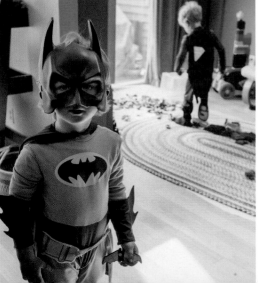

DRESS UP

Have a dress-up party! I've never met a toddler who didn't like to play pretend. Putting on costumes or playing make believe is fun, but it's also a natural developmental progression in early childhood. And of course, it provides endless opportunities for really fun photographs. Lay out the costumes or Mommy's shoes, and step back and observe as the play unfolds.

SPECIAL TOYS

Whether it's a raggedy old blanket or a floppy-eared dog, most little kids attach to a special toy or transitional object at some point. Don't leave out this chapter of your child's story. Photograph Bunny or Blankie or Moose in the special spot where your child leaves it every morning. Get in close and focus on Puppy in the loving grasp of chubby little toddler hands. Remember that the subject of a dramatic photo doesn't always have to be a smiling face. If your child sucks his thumb or uses a pacifier you might be tempted to ask him to stop or take the "binkie" out before snapping off that picture. Don't! Go ahead and immortalize those habits. Though you might not believe it now, one day the habit will be gone and you'll be glad you captured those moments.

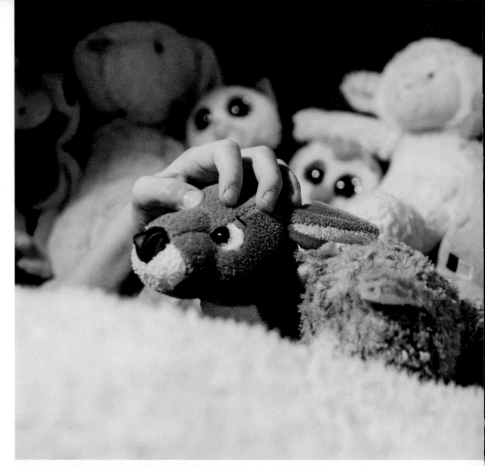

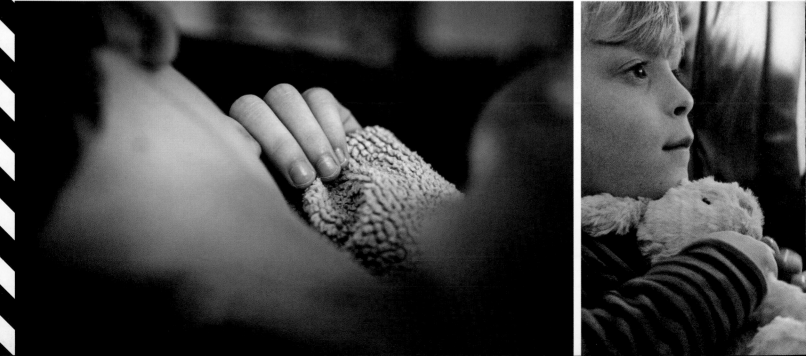

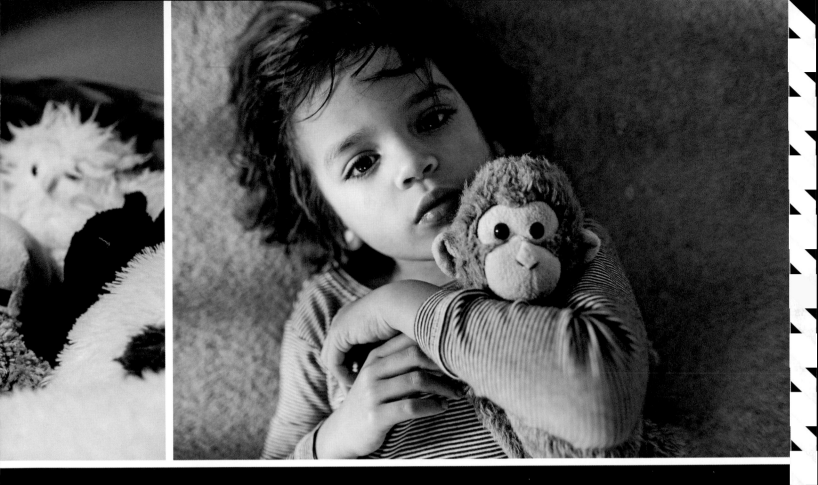

Children often cuddle with a favorite blanket or toy during story time, and the book will give you another layer to incorporate into your image.

FIRST FRIENDS

Young children's play naturally evolves from solo play through stages of parallel play and eventually (around age three) into interactive play. Documenting genuine interactions between children means going beyond asking them to stand next to each other and smile. I love those pictures, too, but to capture true feeling you'll need to be an observer.

Thick as thieves, these two! They've been friends since birth and I've got a whole collection of pictures I plan to present them with at their high school graduation.

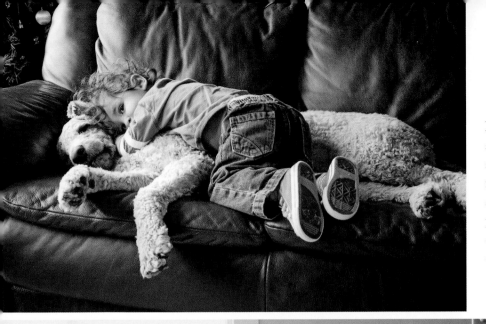

Watch your kids as they play. See what they like to do and learn to anticipate their actions so you're ready with camera in hand. Don't stop them from doing their own thing to pose for you, but do watch the lighting conditions and consider what you want to include in your photograph. If the background is too cluttered, either straighten it up or move yourself to a different position.

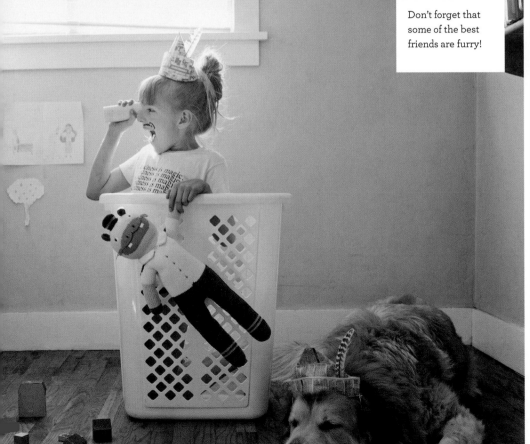

Don't forget that some of the best friends are furry!

Marking the first day of school with photos is a fine tradition (which I never miss) but it was the everyday routine of walking to the bus in the morning that I was trying to capture with this image.

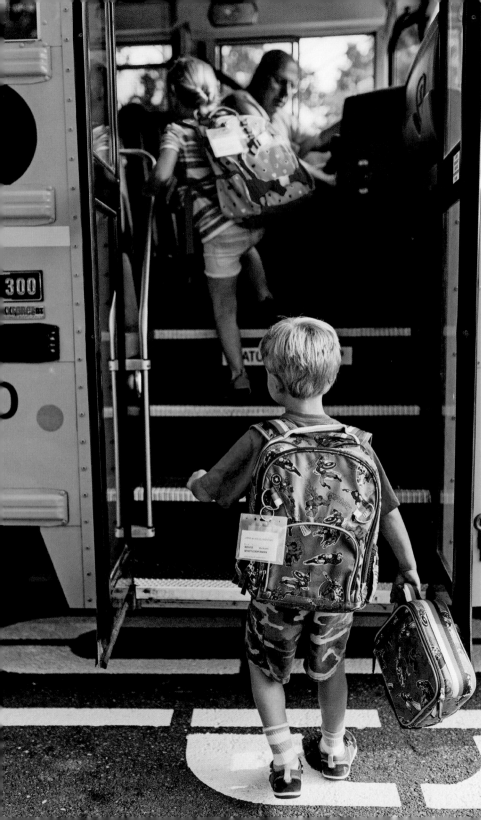

SCHOOL DAYS

A huge part of life as a child is spent engaged in schooling. Whether your child is riding a school bus, walking to school, or setting up for class at the dining room table, documenting the daily routine of learning can make for classic images of childhood. Don't wait for the recitals and the graduations to get the camera out. Capture the bits of it that happen every day.

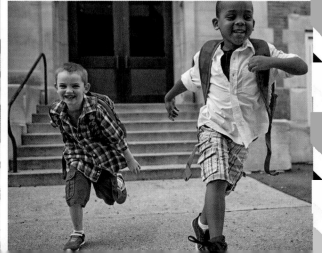

HOMEWORK TIME

My kitchen table gets lovely soft indirect light through the windows in the afternoons, so it's not exactly a coincidence that's where my son sits to do his homework. There he is, all adorable and concentrating, and all I have to do is decide what kind of picture the mood calls for. Some days I step back and observe through the doorway to capture some of the environment of the kitchen. Other days I want to get in close and focus on his expressions.

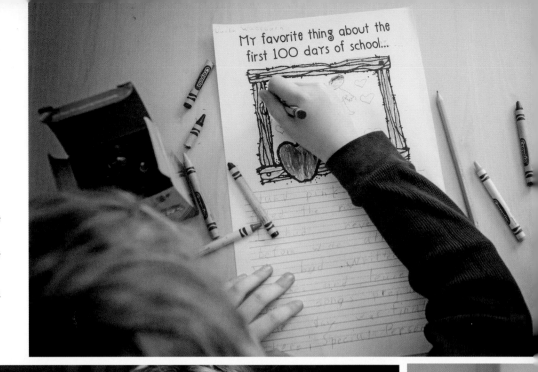

When photographing routine moments, try varying your perspective to keep your collection of images visually interesting.

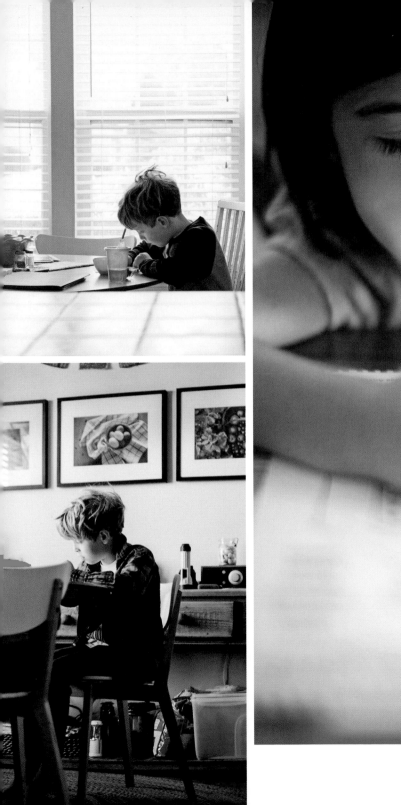
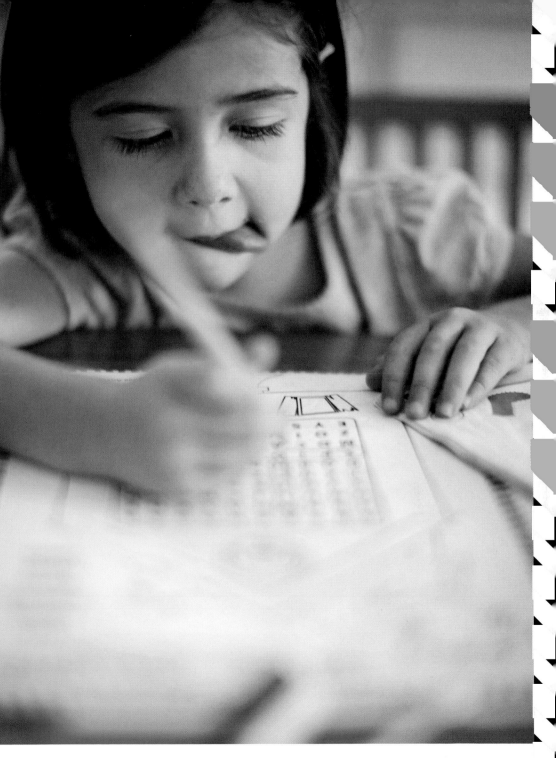

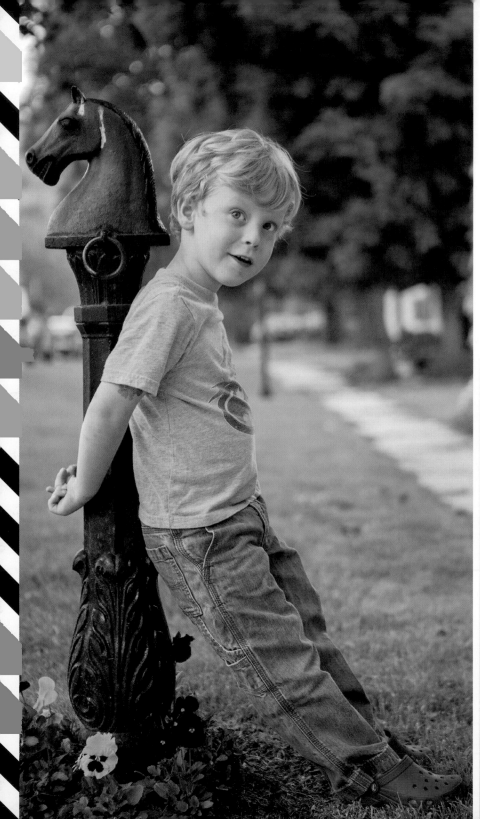

GET OUTSIDE

Kids love to run and roll around in the grass and jump in puddles, and swing on swings and ride on scooters. Photographing outdoors has the advantage of almost always having more light than inside. More light means more latitude to freeze motion. When you're chasing them around, it's a good time to use your camera's Burst or Continuous mode (which takes a few quick consecutive photographs). This way, you're more likely to capture the perfect expression.

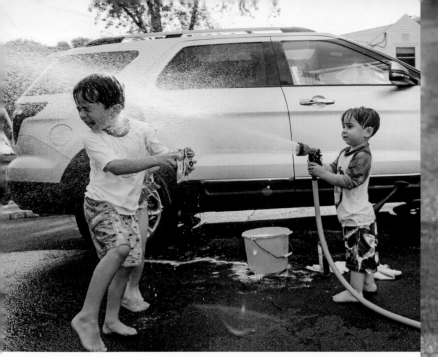

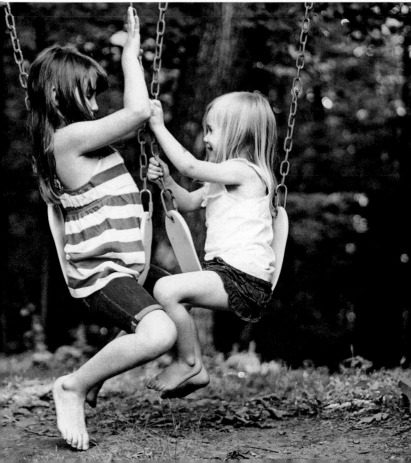

Let the kids be kids and don't ask them for a pose or a smile. Position yourself strategically so that the light is behind them or on their side, set your shutter speed high enough to freeze the action (try 1/250th or above) and let 'em at it.

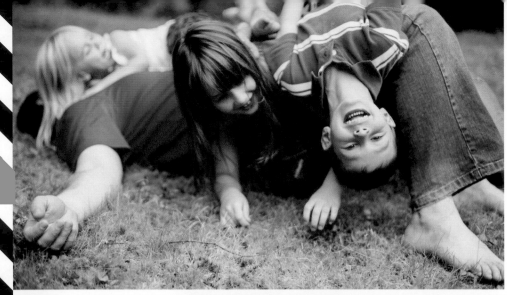

When photographing a fast-moving subject, to avoid motion blur and freeze the motion you'll need to use a fast shutter speed (usually 1/250 second or above). If you're not comfortable using Manual mode, try your camera's Sports mode (if available) or Shutter-Priority mode at a fast setting such as 1/500 second.

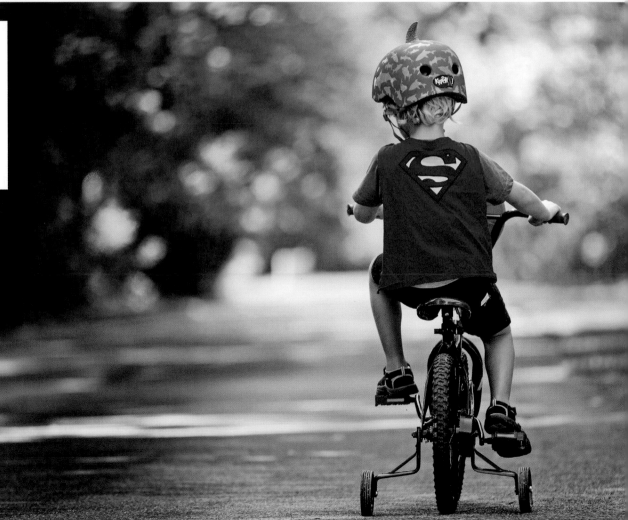

When your subject is moving in a predictable fashion (as with Superman here on the bicycle) you can also try focusing on a spot just ahead of him and firing your shot when he enters the area you have in focus.

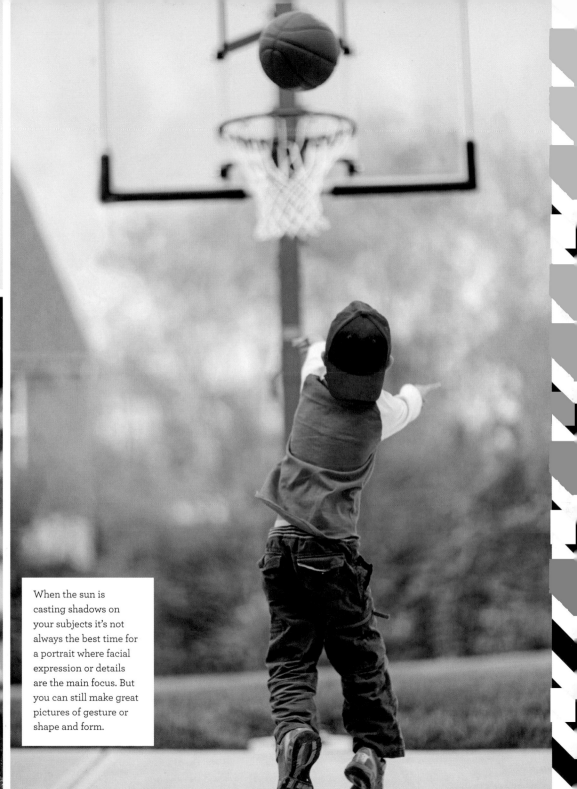

When the sun is casting shadows on your subjects it's not always the best time for a portrait where facial expression or details are the main focus. But you can still make great pictures of gesture or shape and form.

LIGHTING & TIME OF DAY

WHEN SHOOTING OUTDOORS, there may be more light than inside, but that doesn't always make things easier. Different times of day mean different qualities of light. You can't plan spontaneous moments, so prepare for them by taking note of the light in any situation you might want to shoot. If you've got your camera with you, just make a quick assessment of where the light is in relation to your subject. It can even be helpful to do a test shot when you arrive at a new location to make sure your camera's settings are "in the ballpark", giving yourself fewer adjustments to make later on when you're ready to shoot.

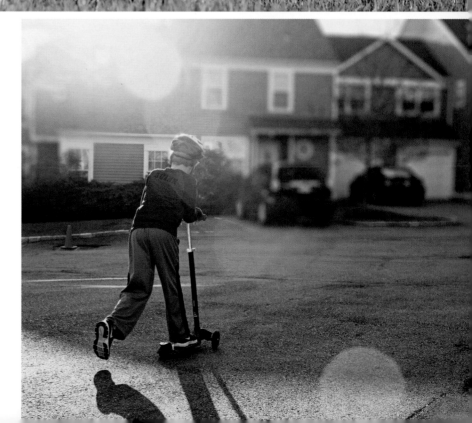

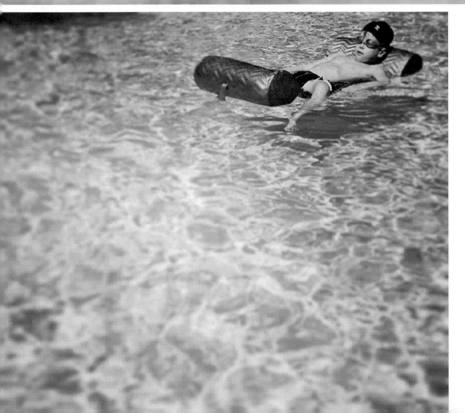

HIGH NOON

At noon, the sun is directly overhead and photographing outside in the sun means contending with harsh shadows on your subjects. This doesn't mean that you shouldn't take your camera out when it's sunny, but it does mean paying attention to how the light falls on your subjects.

 Avoid portraits where bright sunlight is falling on your subject's face. Instead, try capturing images where bright light and shadows enhance your photograph. Try finding some open shade and having your kids play there. Watch out for dappled sunlight (bits of sun falling through the trees), which can create "hot spots" on your subjects, throwing off your exposure.

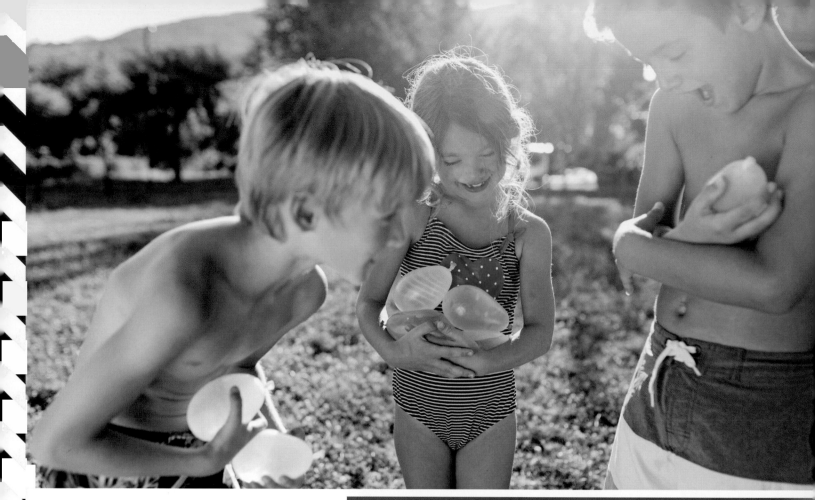

MORNING & AFTERNOON

Early morning or evening hours bring wonderful opportunities for directional and backlit lighting situations. The sun isn't directly overhead, and instead it falls at an angle to your subject, casting shadows off to the sides. The earlier or later in the day, the greater the angle, making for lovely soft light to photograph in.

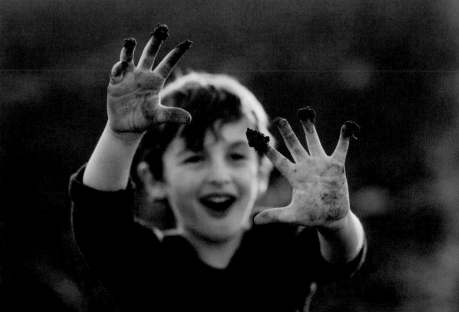

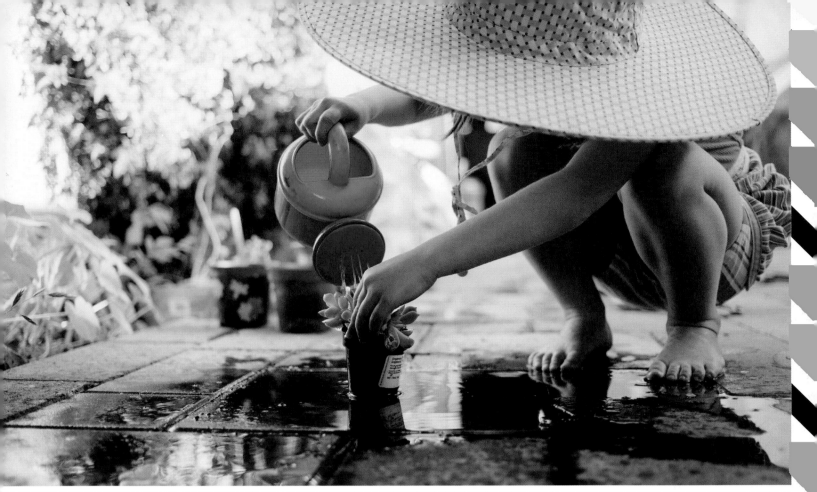

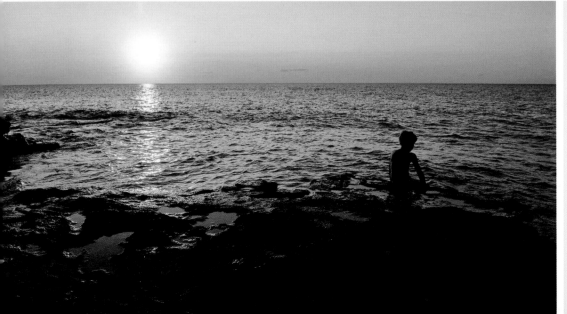

SILHOUETTES

When the sun is behind your subject, you can set your camera to measure the light (meter) for the background (in front of your subject). This will leave your subject in a dark shadow called a silhouette.

SPORTS & ACTIVITIES

PHOTOGRAPHING YOUR KIDS from the sidelines or the audience doesn't necessarily require more than your everyday equipment, but it's very helpful to know what your camera's strengths and weaknesses are before you head out to the game. If you're using a camera phone or have a 50mm lens on your DSLR, you'll want to pay attention to portraits and details more than action shots. For the action shots—especially from afar, you'll do better with a fast telephoto or zoom lens.

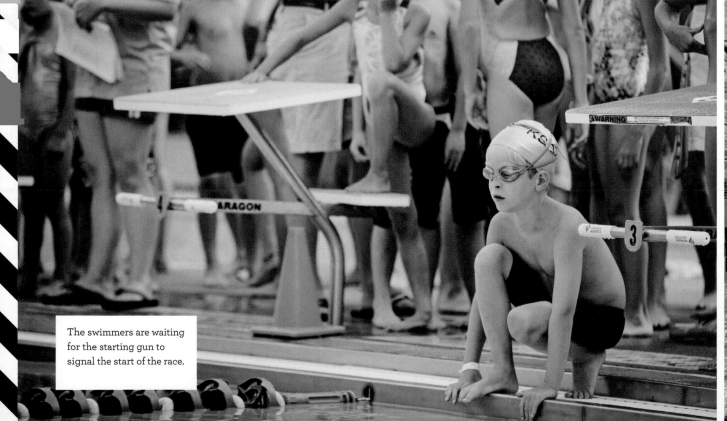

The swimmers are waiting for the starting gun to signal the start of the race.

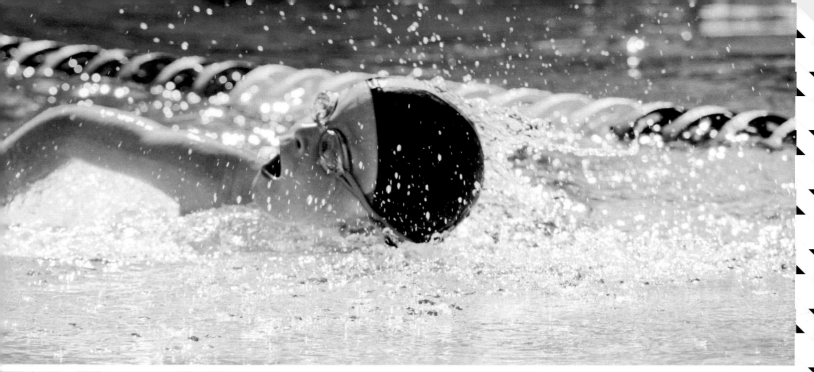

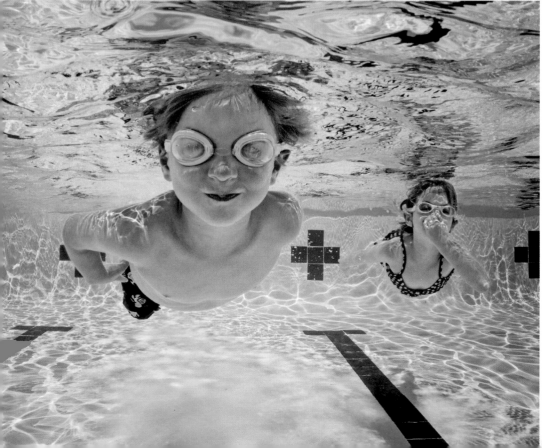

SPECIAL SITUATION: WATER PLAY

Underwater cameras are great for more than just taking pictures underwater. They make bringing your camera to the beach or around the waterpark (or the garden hose in the back yard) much less stressful. Waterproof housings for DSLRs and smartphones are also readily available and easy to use. If your kids love the water, you might want to consider investing in one of these options.

Photographer and mama Holly Berfield captured this suspenseful moment by standing back and observing her son. When the right moment arose, she chose a shallow depth of field (large aperture) and composed the image by using the fence as a leading line. Both techniques work together to draw attention directly to the subject's face.

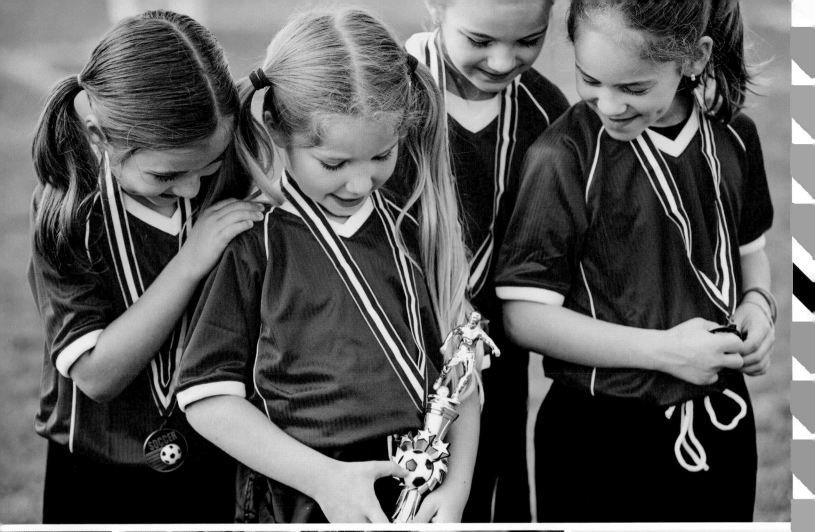

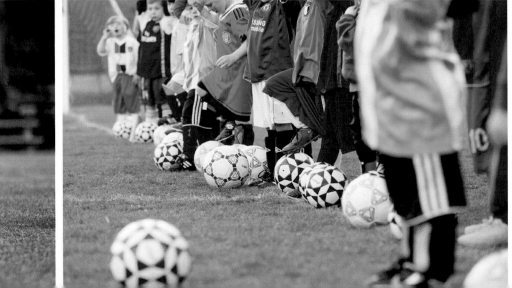

TIP

Instead of always watching the action on the field, take a look at what's happening on the sidelines or in the dugout. Set your camera to expose for and focus on the face of your player and be patient as you wait for just the right moment to capture her expression.

CAMERA SETTINGS FOR ACTION PHOTOS

Setting your camera's drive to Continuous forces it to take a burst of consecutive shots each time you press the shutter. This is very helpful for fast-moving subjects and, along with a fast shutter speed, is one of the most important factors in nailing your focus. Another factor is your selected autofocus mode. Depending upon what kind of camera you have, try using Servo or Continuous Focus to track your subject. Set your focus point over your subject and your camera will continue to refocus as your subject moves, as long as you keep your shutter halfway pressed.

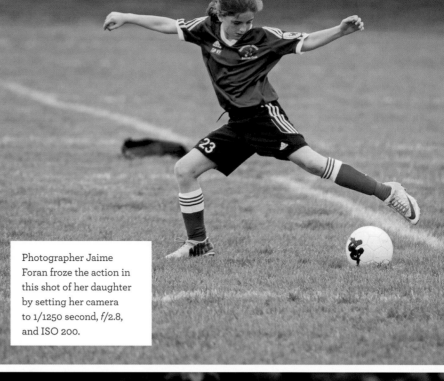

Photographer Jaime Foran froze the action in this shot of her daughter by setting her camera to 1/1250 second, f/2.8, and ISO 200.

FREEZING MOTION

Freezing motion with a camera phone can be especially challenging. Forcing it to take a burst of consecutive photographs will dramatically improve your chances of getting your timing right. To activate Burst mode on most camera phones, simply press the shutter and hold. Your phone will take a series of consecutive images until you release the shutter button. After you're done, be sure to look through and select the ones that work for you, then delete the rest. Otherwise the "rejects" will clog up your storage.

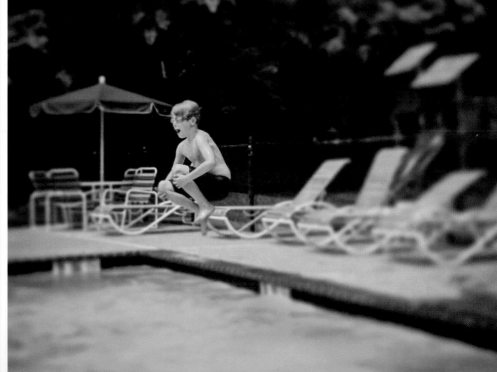

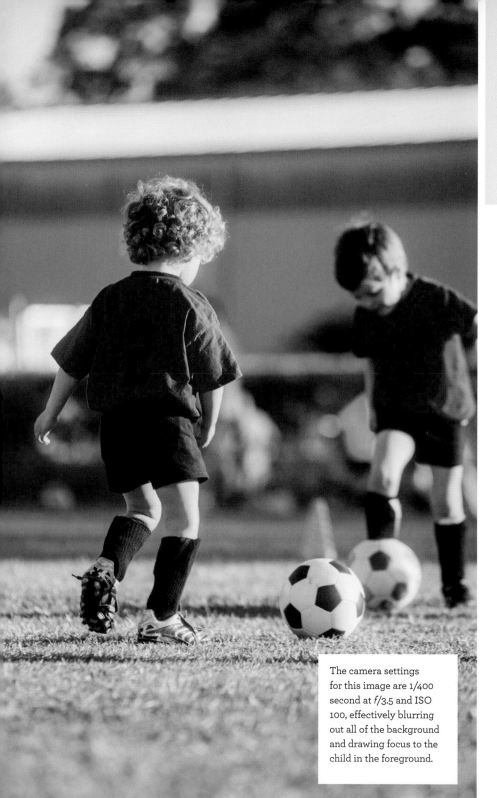

The camera settings for this image are 1/400 second at *f*/3.5 and ISO 100, effectively blurring out all of the background and drawing focus to the child in the foreground.

TIP

To contend with motion blur and freeze the action, use a fast shutter speed. A minimum speed of 1/500 second is needed to freeze fast-moving action.

ACTION COMPOSITIONS

When photographing your kids' sports or activities, you won't have any control over the location so you'll have to make the best of the lighting and the backgrounds. My advice here: Get up. If you stay put and photograph only from your seat in the stands, your images are likely to be filled with distractions that make it difficult to pick out your subject.

When looking for a place to stand, have a look through your viewfinder and see what will be in the background of your picture. Whenever possible (don't forget to make sure you're in a safe zone), find a spot with the least amount of distractions behind your subject and shoot from there. Since it'll probably be hard to find a spot with no background distractions, I suggest using your camera to blur it as much as possible. Set your aperture to the widest setting (smallest f-number) possible to create a shallow depth of field. This will let in more light (helpful since you're probably shooting at a very fast shutter speed) and allow only a small portion of your photograph to be in focus, drawing attention to your main subject.

QUIET TIME

JUST BECAUSE IT'S NOT A DAY that you've got marked on the calendar, or because they're not actively engaged in play, doesn't mean that you should put your camera away. When they're snuggled up with a book or quietly resting, children actually make delightfully easy subjects. It is important to be aware, though, that there's a line (it's different for every family) where stealthily taking pictures of your oblivious children becomes an invasion of privacy. With my kids, it was easy to tell when it happened. They'd see the camera and say "Not now, Mom" (or something slightly less polite).

It's a good idea to make asking permission a part of your process. When I come upon a scene I want to capture, I'll just ask, "May I take a few photos now?," and remind them, "No need for you to stop what you're doing or pay any attention to me." When paying them this respect, I discovered that the answer is more often than not a yes, although, it's often followed by, "Just a few!"

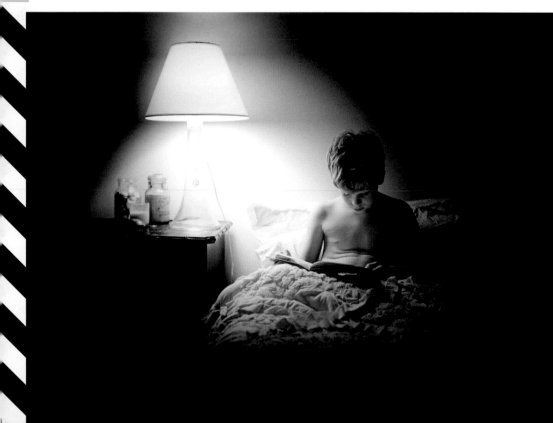

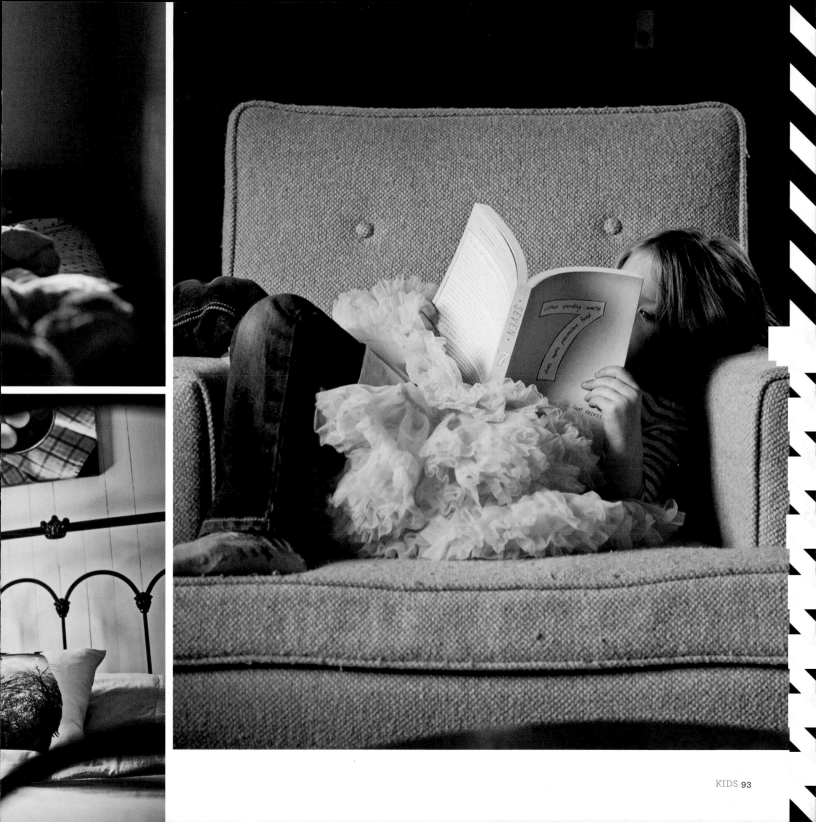

EMBRACING ROUTINE

For most people, the biggest challenge in taking truly authentic photographs of their kids is letting go of the idea that pictures need to be perfect. Life with kids is anything but perfect, and your photos don't have to be either. As an exercise, try keeping your camera with you all day—use your camera phone if you're more comfortable—and take a photo every hour. Your kids probably aren't doing something photogenic every hour; they're just going about their day.

We all know that life with kids moves quickly. And there's so much in the routine of everyday life worth holding onto that you'll miss if you don't remember to look for it. Photograph them doing their chores, brushing their teeth, reading to their dolls, putting on their socks, sulking in the corner— all of it. These moments are what make up their lives, and I promise, you'll be glad you documented it.

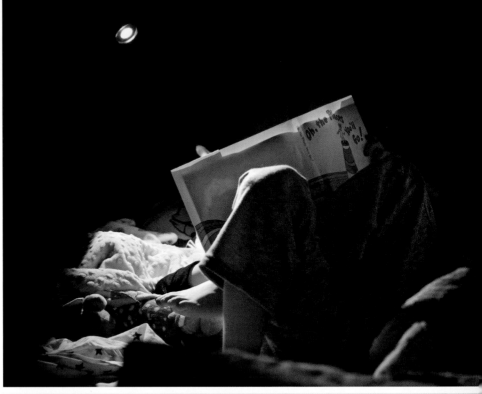

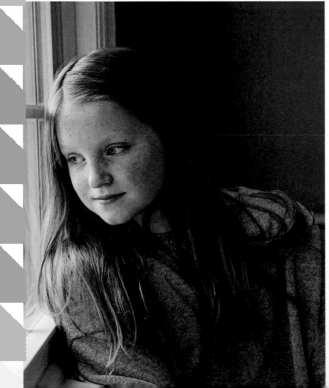

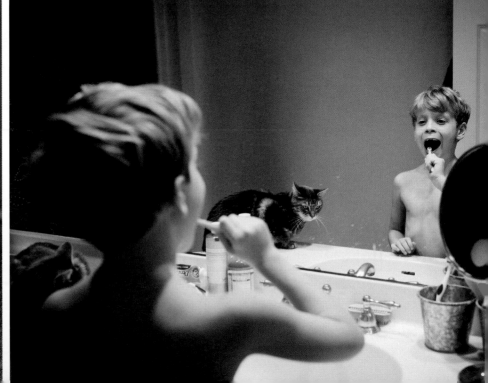

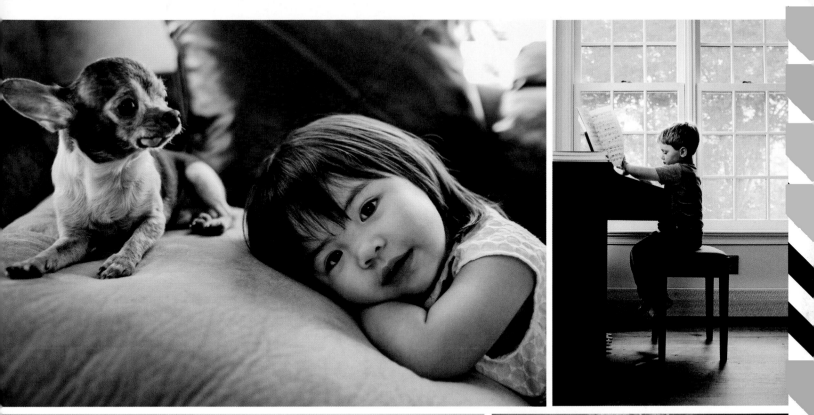

It's these ordinary moments, that occur hundreds of times during childhood, that are the stuff of life with kids.

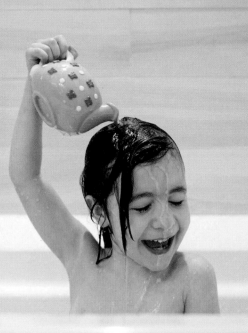

Somebody wasn't in the mood for pictures today.

THE 'TWEEN YEARS

IF YOU'VE BEEN HAPPILY photographing your child since forever and all of a sudden they refuse or get very sullen when they see you coming with your camera, chances are they've entered the 'tween years. Children who were once carefree and completely unselfconscious often become very aware of how they appear and might be uncomfortable having their photograph taken. If I had to quantify such a thing, I might say that the years in between childhood and becoming a teenager are the most difficult to capture in images. They're not little kids anymore and they're not teenagers or adults. Their interests are changing every day and they don't typically want to be around you as much as before. I have found that kids of this age group are most comfortable in their own space, so whenever I can, I use that to my advantage and photograph them in their room.

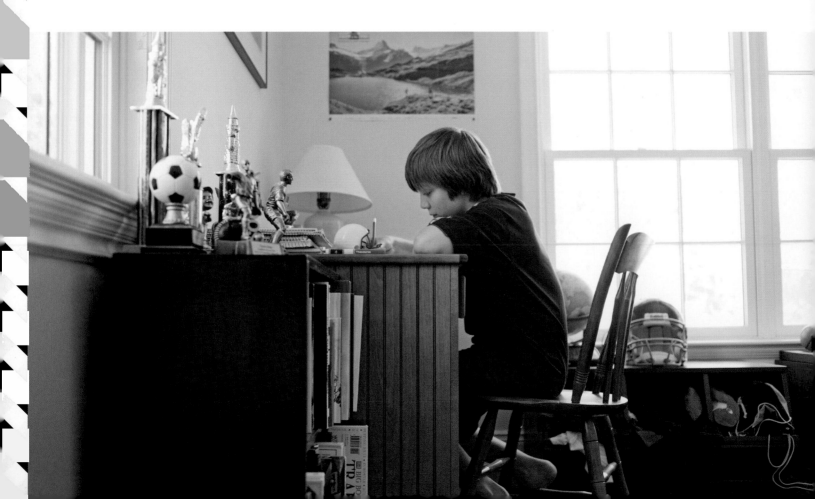

CONSIDER THE ENVIRONMENT

If you've ever been in the room of an older child or teenager, you know that there are clues all around that speak volumes about what they're into. So much of who they are is evident in the details all around them. Teddy bears have been put away (but not too far away) and teen heartthrob posters have been hung on the walls. Sports trophies have earned places of honor upon the shelves, but they're placed right next to favorite picture books that have sentimental value. Leave it all. Now, I'm not saying that it's not a good idea to spend a few minutes straightening up—a pair of dirty undies or other equally embarrassing detail can turn an otherwise successful photograph into something your child will never let you share. I consider it a tradeoff.

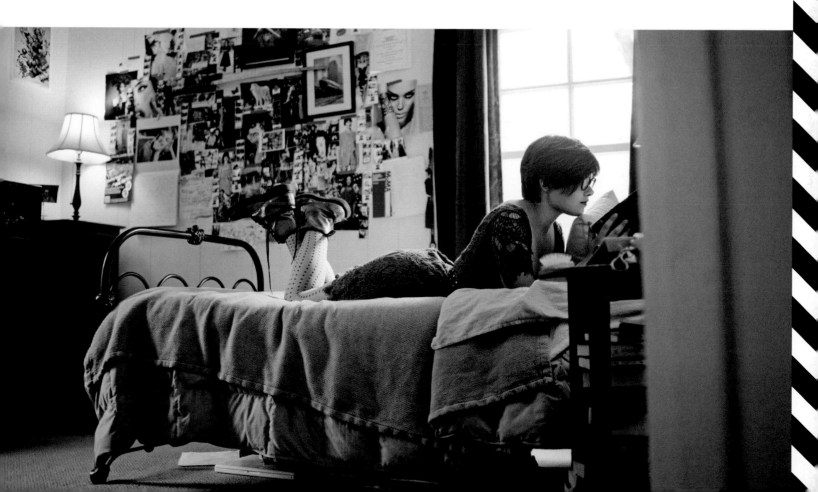

BE REASONABLE

I try very hard not to make unreasonable requests of kids in this age group. If you ask your daughter to "look happy" you'll probably end up with a very forced smile. It's much more organic to allow her to bring her own expression. Where, with younger kids, you might just happen upon them playing and take some pictures, with older kids, you might find that you need to make an appointment—to ask when a good time might be. And when you do find a time, allow them to come as they are (don't ask them to change their clothes or redo their hair). This will go a long way toward being allowed into their world. Photographs of them talking on the phone or playing video games may seem mundane to you now, but one day, I promise, you'll cherish the slice of life, as they were at that moment in time.

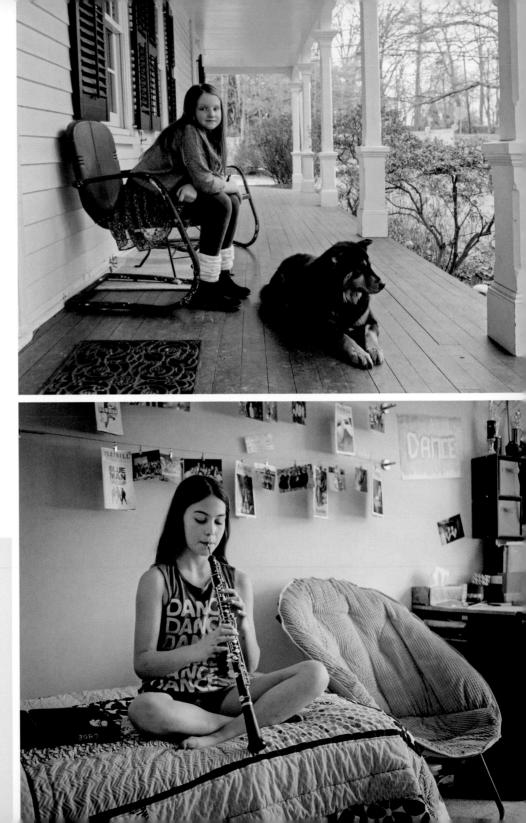

TIP

Use a wide focal length to include as much environment as you can to let as many details in.

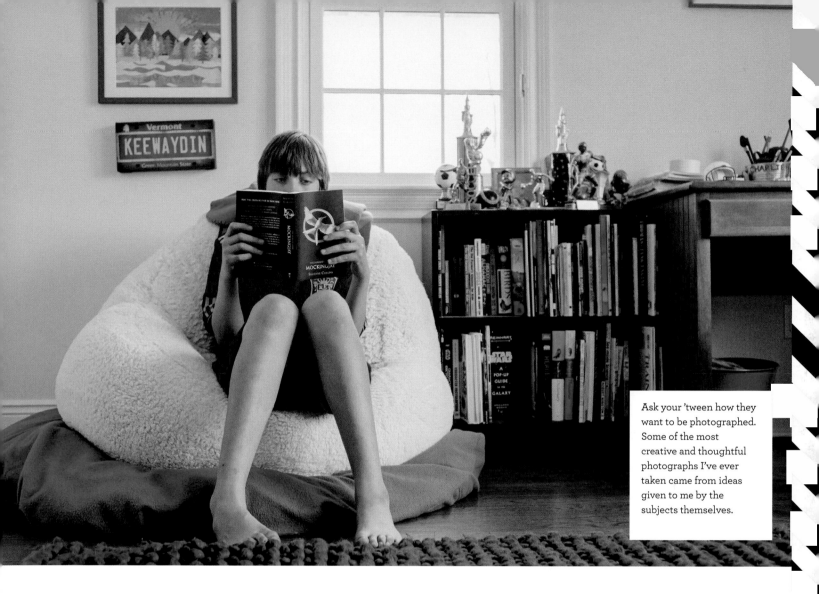

Ask your 'tween how they want to be photographed. Some of the most creative and thoughtful photographs I've ever taken came from ideas given to me by the subjects themselves.

PROVIDE DIRECTION

If you've gotten your 'tween to agree to a photograph (congratulations!), help the moment along by providing him with a little direction. While you may not be asking for smiles, he may feel awkward and not know what to do. Don't leave him hanging. Reassure him that you're not going to embarrass him and that you'll show him the pictures before sharing them anywhere. Also, and this is one of my favorite techniques, so read carefully: don't be above bribery. (In my family, half an hour of extra screen time is valuable currency.) And, in the end, back off! Know when to say when.

TEENAGERS

IF THE THOUGHT of photographing your teenager fills you with dread, you're not alone. Where the 'tween years were hit or miss, the teenage years may be more miss than hit. Moods are predictably unpredictable and photo opportunities are fewer and farther between. Gone are carefree afternoons playing with blocks or dressing in costumes, replaced now with homework and new interests, and hours spent behind closed doors. No doubt about it, photographing teenagers is a challenge. It's not impossible though, so don't pack your camera away just yet.

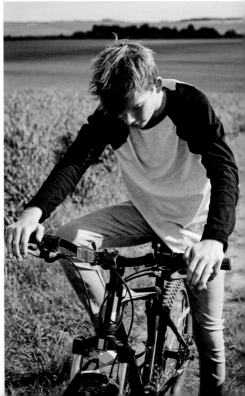

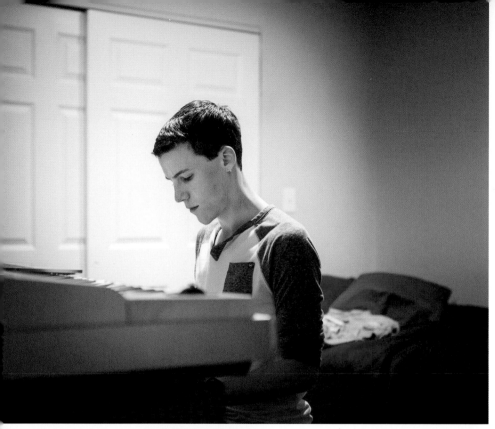

PROPS

I know what you're thinking: props sound pretty orchestrated and kind of the polar opposite of everything we've discussed up to this point, and you know what? You'd be right. Props certainly can make a photograph appear very staged and stiff, but desperate times call for desperate measures, and photographing teenagers is such an occasion.

I'm not going to suggest you place a grand piano in the middle of a cornfield. I'm just talking about giving teens something to keep them busy in the photograph to take their mind off the fact that they are having their picture taken. Hopefully, this will allow you to catch some genuine emotion. Does your teenager play guitar? Love video games? Fashion? Play lacrosse or basketball? Whatever it is, chronicle their interest while simultaneously giving them something else to focus on.

LOCATION

Pick a location that has visual interest or one that has meaning to your teenager. Does he or she love the beach or the city? Allow them to set the scene and, of course, choose what they wear and you'll find that their comfort level will increase.

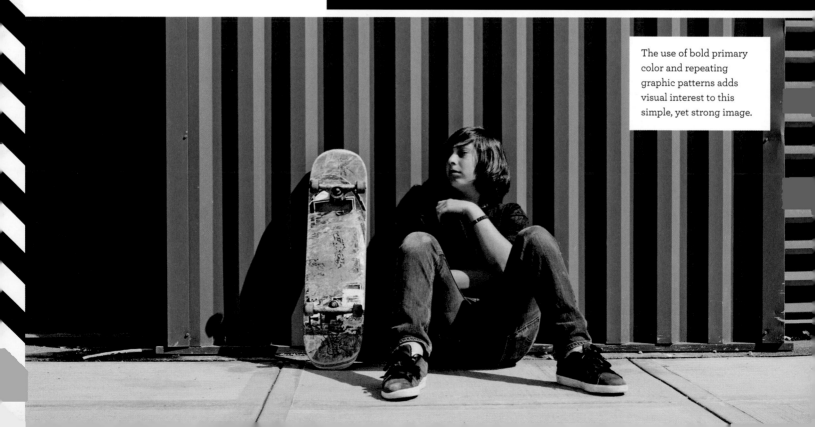

The use of bold primary color and repeating graphic patterns adds visual interest to this simple, yet strong image.

I shot this picture of my son with my camera phone in the parking lot behind a diner where we had lunch on our spring vacation last year.

POSED PORTRAITS

STRIVING FOR AUTHENTICITY and a natural feeling in your family photographs in no way means that there isn't a place for posed portraits in your collection. In fact, it's really just the opposite. I encourage you to take posed portraits of your kids during as many stages as you like, but I want to give you the skills to move beyond "center, smile, snap" to make creative portraits that really speak to the personality of your subject.

DRAMA BOY

In this 17-year-old portrait of my son, Jake, the light is coming from his right side at almost a 90° angle, creating dramatic shadows on the left side of his face. The background is stark and I chose to compose the image by getting very close and almost completely centering him as he made direct eye contact with the camera. All that coupled with the black-and-white conversion make for a very confrontational portrait (which pretty much sums up what it felt like to live with him around then).

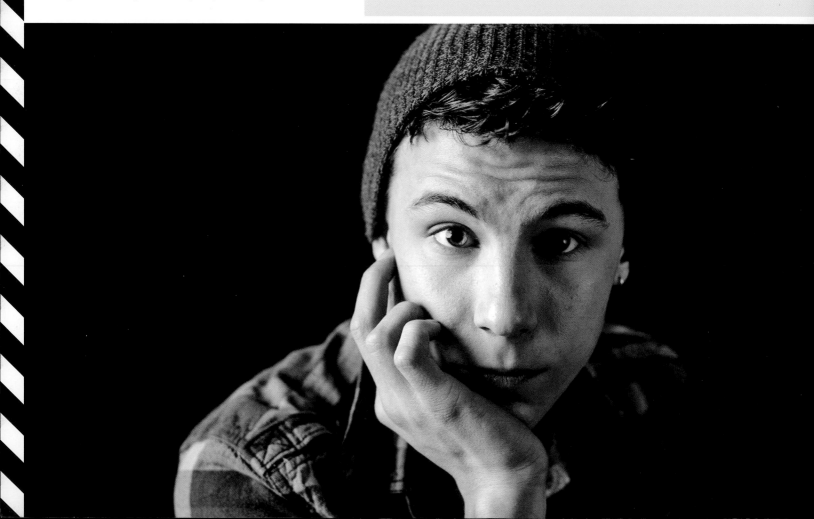

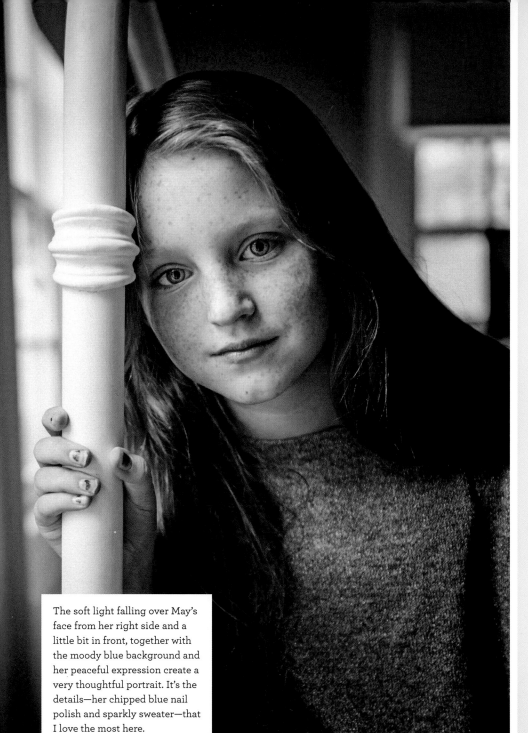

The soft light falling over May's face from her right side and a little bit in front, together with the moody blue background and her peaceful expression create a very thoughtful portrait. It's the details—her chipped blue nail polish and sparkly sweater—that I love the most here.

TIPS FOR SUCCESSFUL PORTRAITS

- **Light:** Flattering light is soft and indirect. Place your subject with the light coming from the side and slightly in front.

- **Angle:** Hold your camera at eye level or just above. For younger children, this usually means crouching down.

- **Focus:** Make sure the eyes are in focus, especially if you're using a shallow depth of field. If your subject is at an angle to your camera, focus on the eye closest to the camera

- **Crop:** Get in close to your subject (either by standing close or using a telephoto lens), but be careful not to crop at any body joint (i.e., at the elbows or knees).

- **Composition:** Portraits are most dramatic when there are no distracting elements in the background. If you're shooting someplace where there is a cluttered background, either remove unwanted elements before taking the portrait or use a shallow depth of field to blur the background (or both).

FAMILY

From **baby's first steps** to **Senior Prom** and everything in between, your lives as a family are made up of millions of **beautiful ephemeral moments**. If you're only dusting off your camera for the milestones, you're missing out on documenting the stuff of your every day lives together. The **daily details** and **routines** and **emotion** may not feel photo-worthy when you're in the thick of it, but I promise you, taking the time to pick up your camera and focus on the ordinary will have **an extraordinary payoff** down the road.

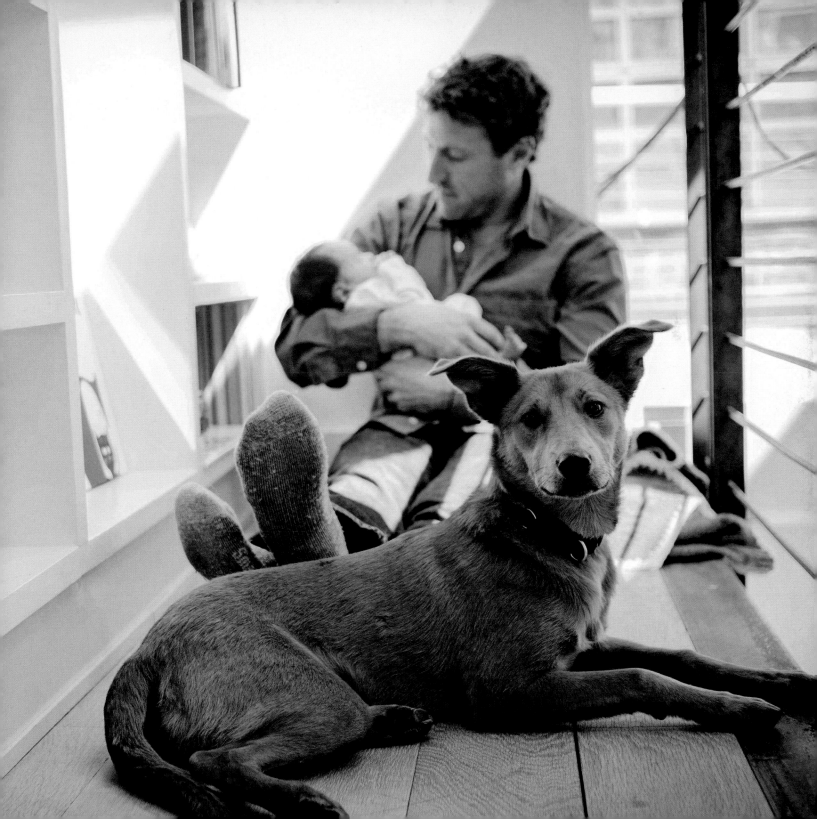

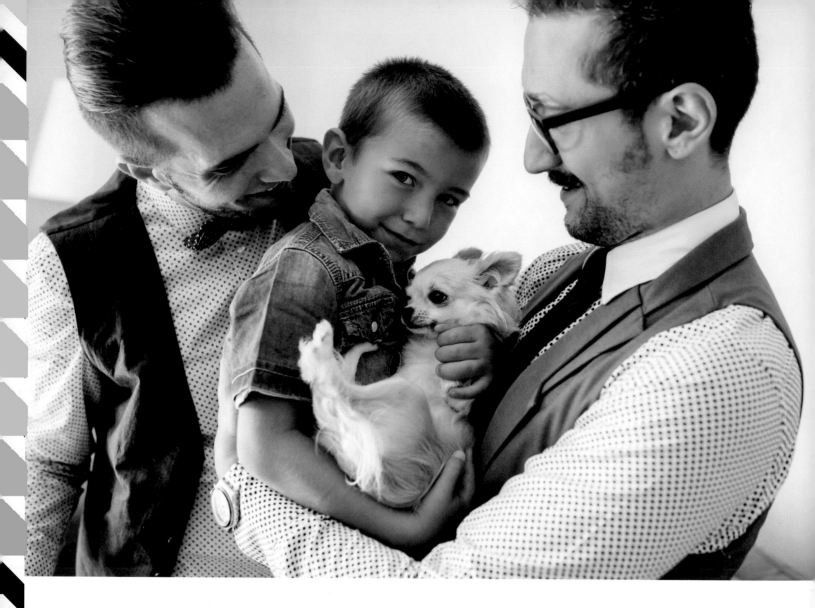

COME AS YOU ARE

WHEN PHOTOGRAPHING family together, your approach doesn't have to be any different then when photographing your kids alone. Let everyone be themselves, look for genuine feeling, and don't force it. Set yourself up for success by always seeking out the best light and remembering the basics of composition and exposure.

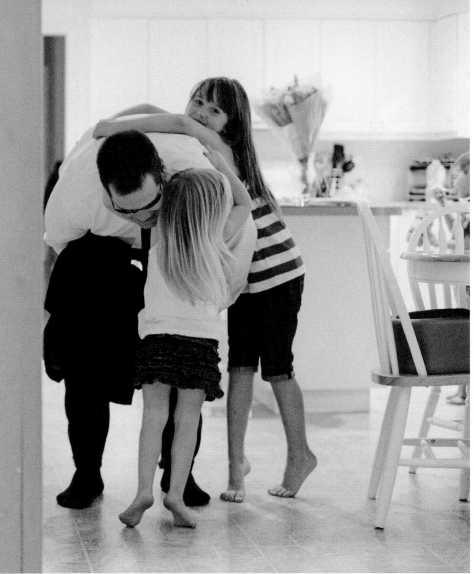

With multiple subjects, instead of looking only for emotion from one person, be on the lookout for interaction between the subjects. If you focus on the connections among your family members, your pictures will truly show the essence of what your family is about. And don't forget that you, the family documentarian, are part of this story too, and you need to get in the picture with everyone else some of the time.

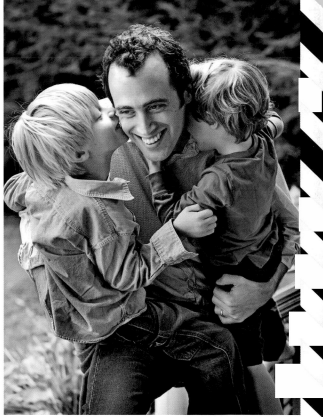

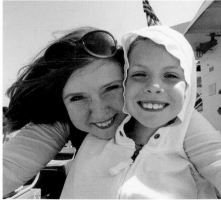

GET IN THE PICTURE

FIRST, I'LL TELL YOU WHY I feel so passionately about you getting in your family photographs, and then I'll tell you how to do it. Most of the mothers that I speak with say that they're the family photographer, so I'll address this advice to moms—but if you're a dad reading this, the same ideas certainly apply! Where young children are typically blissfully unselfconscious, the opposite is almost universally true of adults, particularly women. We're often overly critical of ourselves when it comes to appearance, especially when we're overwhelmed with the business of juggling family and work, and home and relationships, and everything else that comes with leading a full life.

Just like with kids, if you're waiting for a magic moment when everything comes together and you feel perfectly ready for your closeup, you might be waiting a very long time.

When I look at this picture of my mother (above left), I don't see a woman with imperfections. I see a woman who was there in the water with me, present in the moment, playing with her small child. I see a beautiful, happy mother, and I'm eternally grateful that she handed the camera to my father and stepped into the picture with me. If you can't bring yourself to do it for you, do it for your children. One day, they'll thank you for it because they want to see that you were there, too.

1-2-3-go! For this shot, Gina was all set in place and in focus when she asked the kids to come running at her. As soon as they landed in her arms: click!

TAKING A SELFIE

Of course, you can hand the camera to someone else in order to get into the picture with your kids (and you should!), but that's not always possible. The easiest solution might be an arms-length selfie. You can do this with a camera phone or any camera that isn't too heavy. Hold the camera slightly above you for the most flattering angle and whenever possible, turn around so that the light is falling onto your face and not at the back of your head. This process is made easier if you have a camera with an LCD screen that flips around to show you the image as you're taking it.

My friend Kelly travels a lot with her young daughter and they like to document where they've been with selfies!

USE YOUR REMOTE CONTROL

Every now and then, it's also nice to be able to have photos of yourself actually interacting with your kids (i.e., not holding a camera). At these times you can set your camera on a flat surface or use a tripod and take advantage of your camera's self-timer function. Even most camera phones have timers. Another even easier solution is to purchase a remote control shutter release for your camera and trigger the shutter once you're in the frame and all set up.

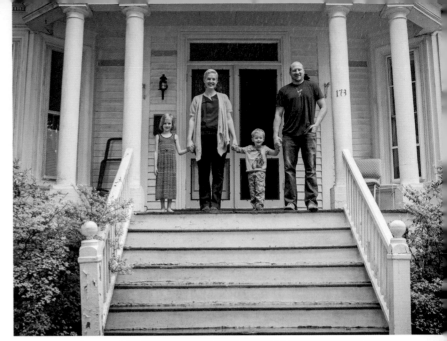

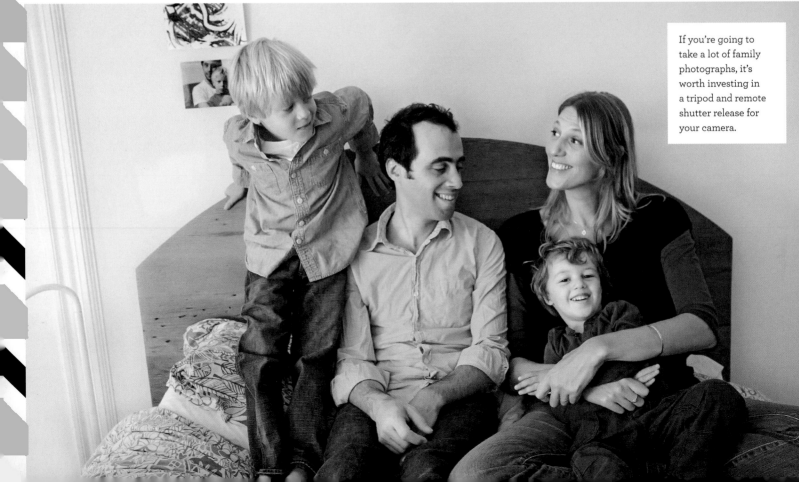

If you're going to take a lot of family photographs, it's worth investing in a tripod and remote shutter release for your camera.

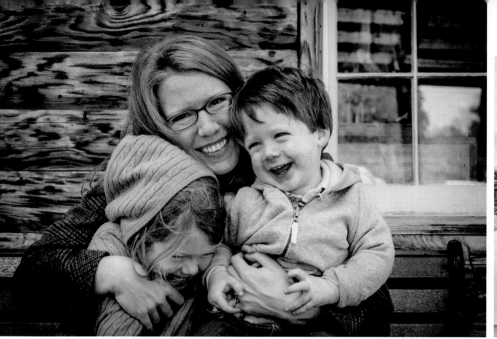

Try laying your camera directly on the ground or on a stack of sweaters or books—anything sturdy and dry. Just have a look through the viewfinder to compose your image, set the timer, and go get in the picture!

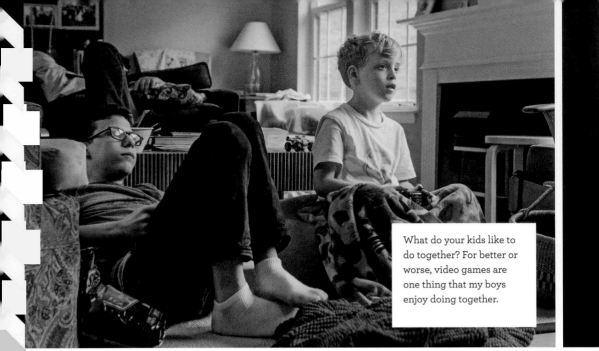

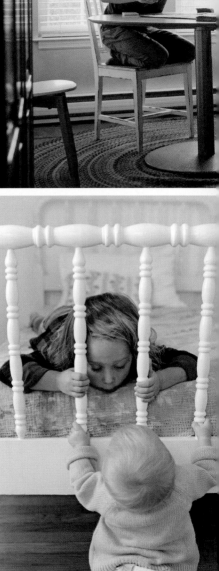

What do your kids like to do together? For better or worse, video games are one thing that my boys enjoy doing together.

SIBLINGS

PHOTOGRAPHING YOUR KIDS together doesn't have to mean everyone is happy and looking at the camera. After all, how many minutes of the day do your kids spend with their arms around each other with big smiles on their faces? Capturing everyday interactions between siblings can mean anything from sulky, pouty, furrowed brows, to wrestling matches and tickling fights, to perfect little angels playing so quietly that you wonder what's wrong. Any parent knows that if you attempt to stop the moment to immortalize it, it might just blow up in your face and disappear forever—just another reason that it's especially important to be prepared with a camera ready to photograph when the moment arises.

Sometimes it takes a few well-placed toys or games to get siblings to interact. When you're setting out the activities, take a quick look at the light in your room and, whenever possible, strategically place the toys in the softest indirect light. And, as ever, don't let a seemingly "imperfect" scene stop you from capturing the photo!

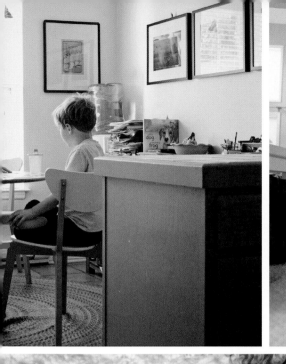

Using a wide angle allows you to capture the environment around the subjects, giving context to your image.

Framing your image by cropping in tightly with a close angle gives a feeling of intimacy.

COMFORT ZONE

HOME: IT'S WHERE everything happens. Everyone is at their most comfortable at home and, as far as I'm concerned (keeping privacy concerns in mind, of course), nothing is off limits. I've been known to photograph my kids brushing their teeth or doing their chores or, yes, even potty training. These are the things that make up our days and I'm all too aware of how quickly they'll be gone. And don't forget that your house is also an important part of your family. Though it will be a backdrop to all of the pictures you take there, don't forget to feature it front and center every now and again.

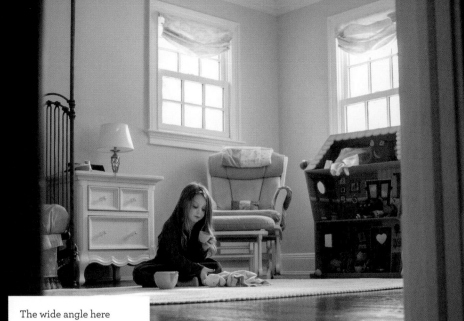

The wide angle here allows for both creative framing using the doorway and enough environment to really set the scene.

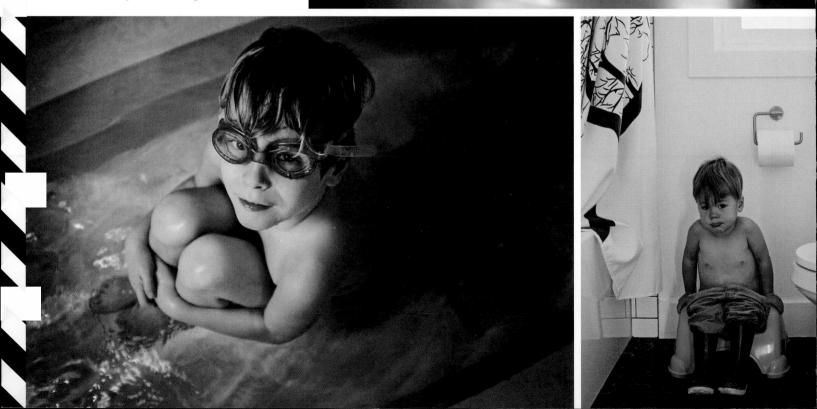

When I'm home, I keep a camera nearby and charged at all times. My favorite lens for taking pictures indoors is my 35mm because I can stand back, removed from the action, and shoot the environment and subjects in the same frame.

THE BACK YARD

FOR MANY OF US, "the back yard" is synonymous with childhood. It's a place where friends gather and kids run free. Backyard fun spans any age gap, and with a little imagination anything can happen. Watch the light in your back yard at different times of day and over the course of the year, and notice where the sweet spots are. If you're outside in the brightest part of the day, remember to look for the shade. If you can get outside in the hour or two before sunset or early in the morning, you'll be able to take advantage of "golden hour" light and your photographs will glow with that magical, soft lighting.

KIDS WERE HERE

Life with kids means life with kids' stuff. I admit, it wasn't always easy for me to accept the mess that arrived in my house not long after my children did. I can't pinpoint exactly when it happened, but at some point I changed my tune and began to see their toys as a sign of days well spent. Block structures on the living room floor and art projects taped to the fridge were the byproduct of hours of productive play. So, sometimes, instead of cleaning, I turn the camera on the mess and try to embrace it.

SEASONS

DOCUMENTING THE PASSING of the seasons is a wonderful way to mark your family's growth. Focus on what makes each season special to your family, noting any traditions or seasonal rites of passage. Start a family tradition of remaking the same photograph or visiting the same location year after year.

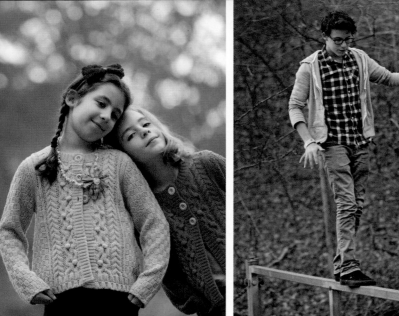

AUTUMN COLOR

Autumn color provides a spectacular backdrop for outdoor photos. To make the most of the bright hues, get out early or stay out late to take advantage of directional sunlight. But don't put your camera away just because the sun isn't out. Autumn colors appear especially intense on overcast days. And when the leaves have all turned brown and fallen to the ground, don't discount the splendor of the muted tones.

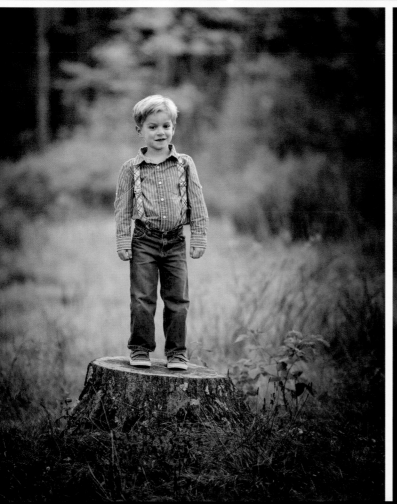

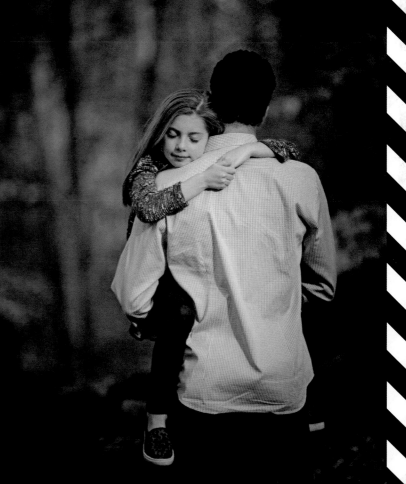

SNOW DAYS

Snowy pictures require a little bit of extra camera work to properly expose for the bright white. Set your camera to overexpose (check your manual for exposure compensation) a little bit to make sure the snow doesn't read as gray and muddy.

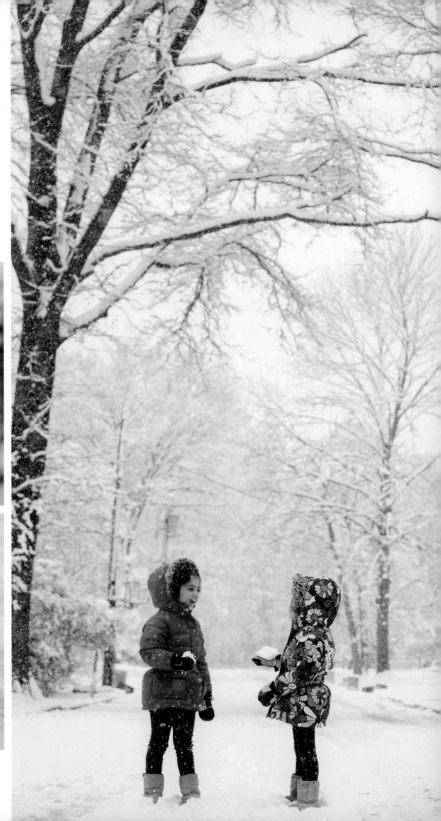

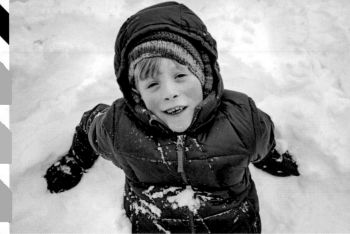

In a snowy situation, contrast can be tricky. All of the subjects on these pages really stand out because of the bright colors they're wearing.

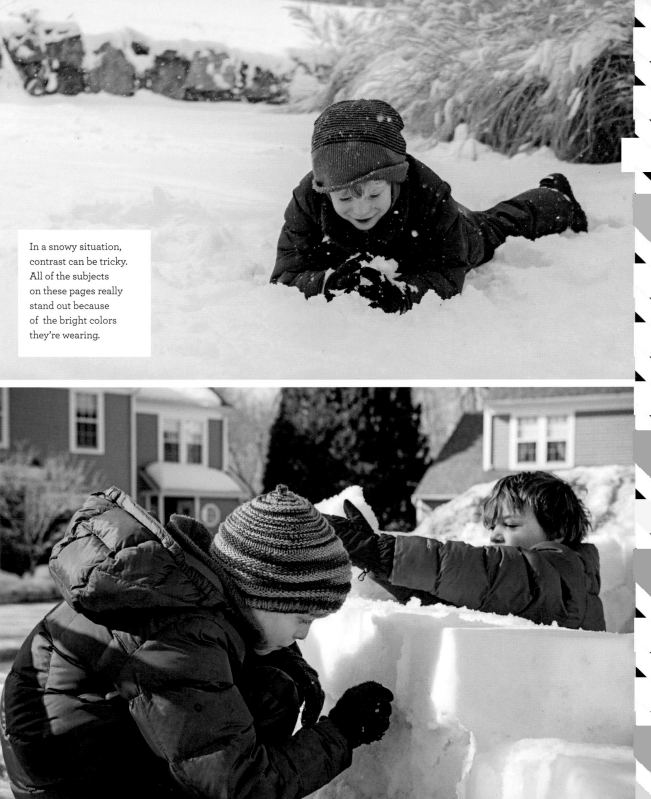

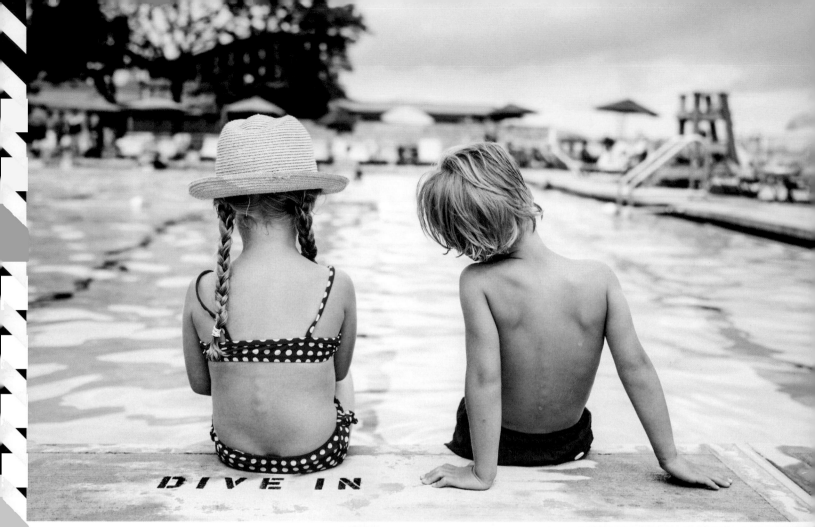

SWEET SUMMERTIME

Summer is my favorite season. Everyone is more carefree and time seems to slow down. No one is weighed down by winter coats or boots (or schoolwork), and we're outdoors all day long. Summer adventures and activities make for colorful photographs and the light seems to go on forever.

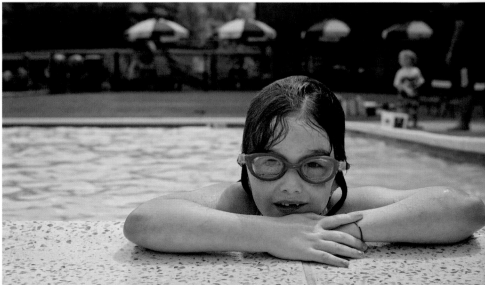

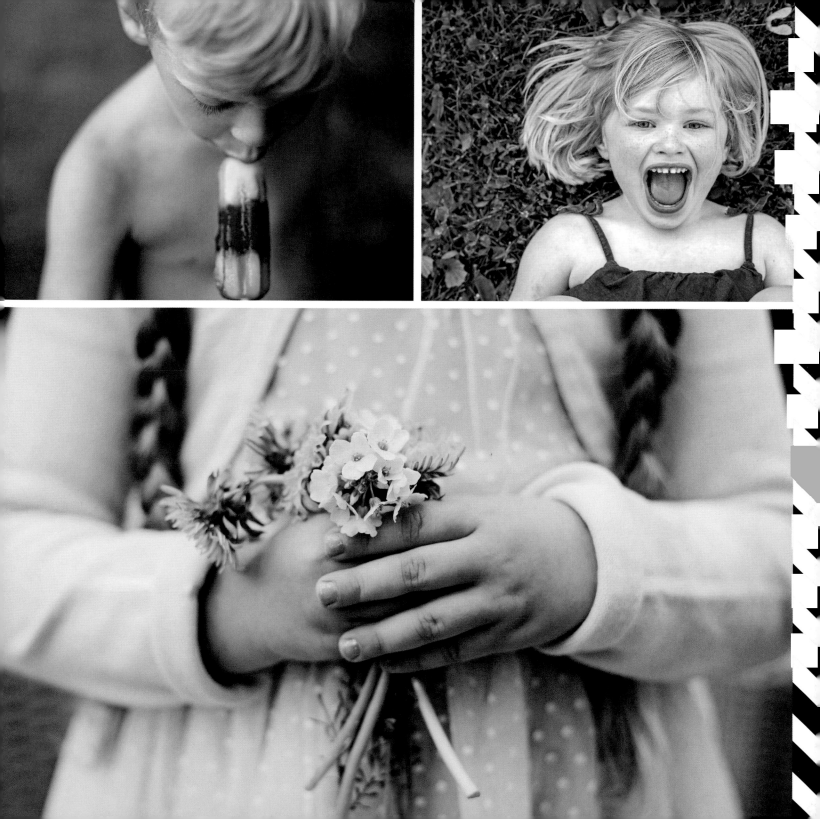

IN THE CITY

TAKING PICTURES of your family against the backdrop of the city means lots of color and texture, and fast-moving subjects. Position yourself so that you can incorporate the surroundings behind your subjects to get a real sense of how big everything is (and how little they are).

Step back or use a wide angle lens (or both) to incorporate the environment in your photo. For this picture of my son in Central Park, I only had a 50mm lens with me, but I stepped back far enough to get the steps and the trees surrounding the statue into the frame.

Photographer and Mama Tara Romasanta used a shallow depth of field (wide aperture) for this shot, which blurred the background and really gets her adorable subject to pop.

AROUND TOWN

GET IN THE HABIT of taking your camera when you're out and about. Photographing your kids as you go about your daily routines doesn't have to be obtrusive. Wait until they're engaged and take a few snaps, and back in the bag goes your camera. If you're uncomfortable pulling out the big camera in more intimate locations, try using your camera phone.

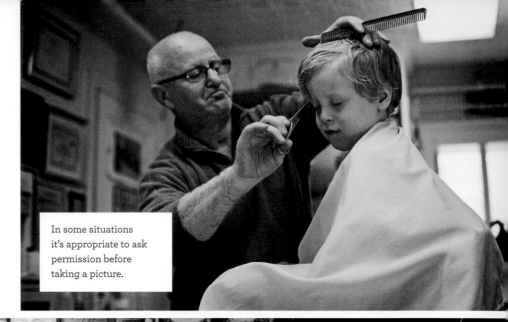

In some situations it's appropriate to ask permission before taking a picture.

My kids are used to it now, but you might need to let your subjects know that they don't need to stop what they're doing and look at you or pose just because you took your camera out.

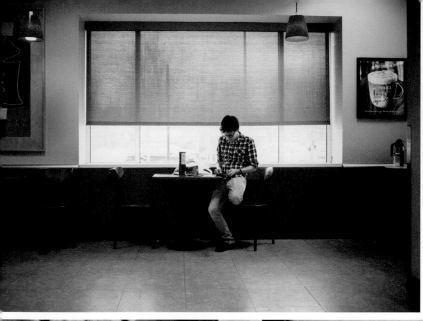

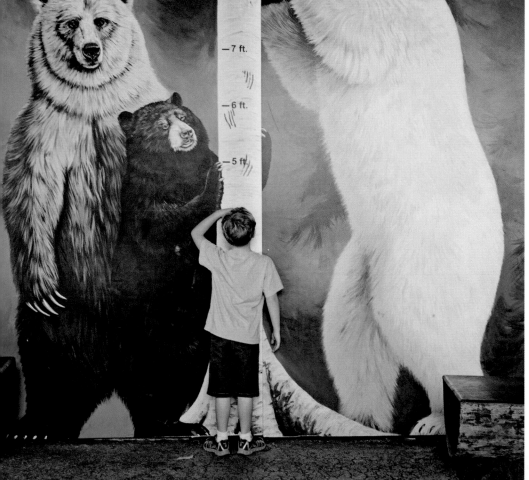

Photograph your favorite places—the places you go every day, such as the library, the corner coffee shop, or the supermarket. Taking a field trip? Photograph your children's visits to the museum or aquarium. Skip the "we were here" photograph of everyone standing in front of the building smiling and go for a picture of your child as they observe the exhibits.

ON VACATION

FOR MOST OF US, traveling with our kids falls outside the realm of daily life, but that doesn't have to change your approach to documenting vacations. Consider the whole vacation and what it was like to be there. Is it a place you go every year or some great adventure? Tell the story from the beginning. Start with the traveling and take some pictures in the airport or as you load up the car. Think beyond the posed shots of everyone standing in front of the national monument (but, of course, you can take those, too).

Our family's annual vacation takes us to the beach every summer. We have certain traditions and rituals (places we always go and things we always do) that we look forward to, no matter how many times we've done them before. I can photograph these same things each summer and never tire of the result. The boys are growing and these photographs are a yardstick by which I can measure their growth. Vacation is also a time to break out of the routine. Get up early and go to the beach at sunrise to capture the uniquely beautiful morning light.

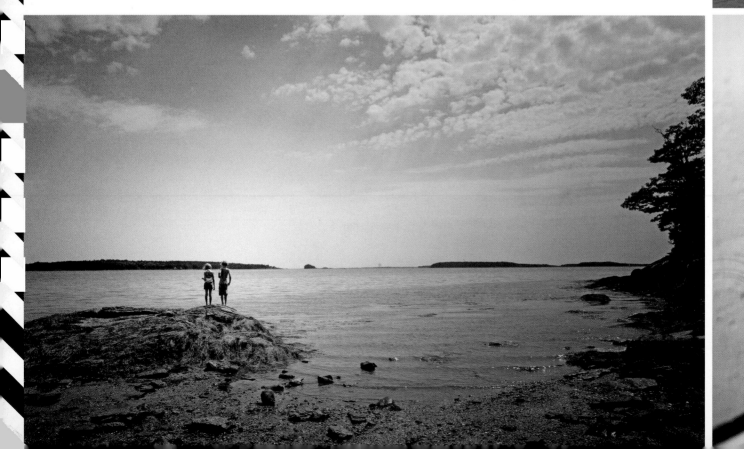

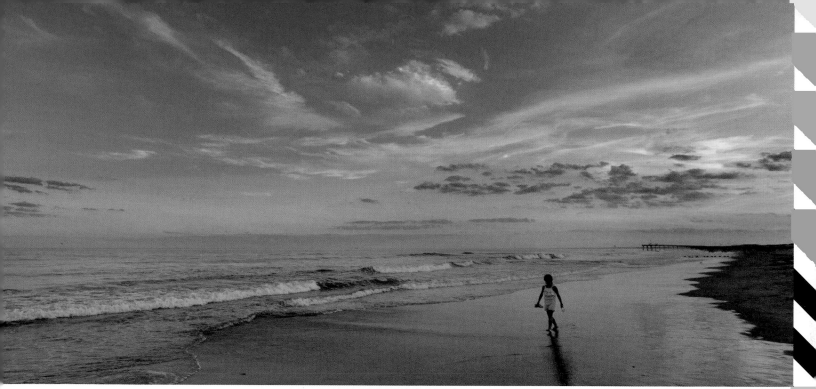

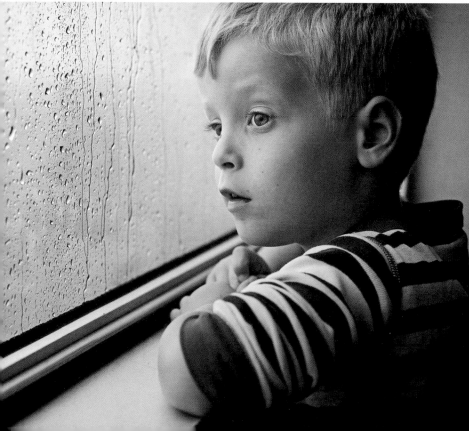

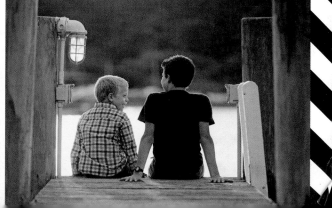

THE CLASSIC FAMILY PORTRAIT

I'VE SPENT A LOT of time up to this point talking about natural and un-posed photographs. I'm going to turn it around now and encourage you to gather your family together and pose for some photographs as a unit. If you are so inclined, hiring a professional is a great idea. Professional photographers will help you with posing, location choice, lighting, and framing, and will release you from all of those worries, allowing you to just be with your family.

That said, you don't necessarily need a pro to take a family portrait; you can do it with a tripod and a self-timer or a remote trigger. Gather everyone up and get in close. Don't be afraid to snuggle or tickle and get everyone laughing. A great portrait doesn't have to be stiff and uptight.

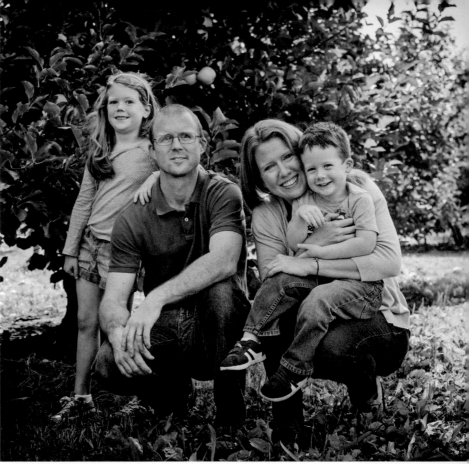

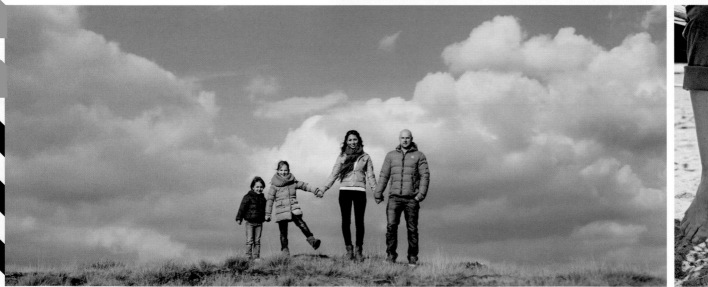

PHOTO SESSIONS

Placing as much value as I do on authenticity in my family photographs doesn't in any way devalue photos that are the result of some planning and direction. Sometimes, it's lovely for everyone to tuck in their shirts, brush the hair out of their eyes, and step into the golden light.

Plan a photo session with your family. Pick a time when everyone is agreeable, dress them all up, and plan out the details. Scout a location where the background is pretty and not distracting (or just clean up the living room—and the kids) and voila! You'll have a family portrait for the ages!

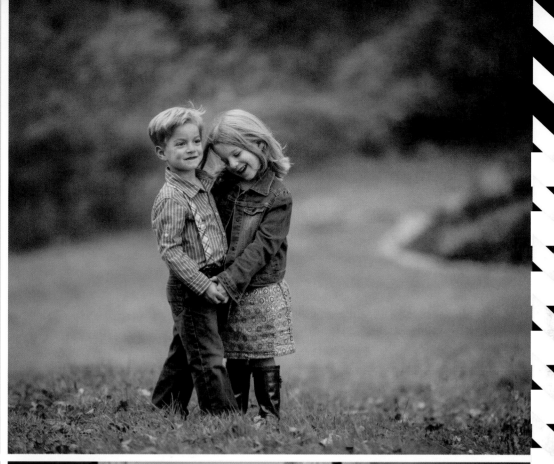

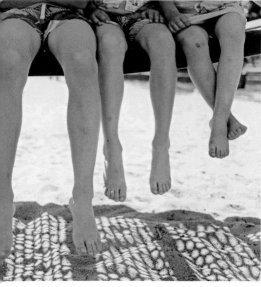

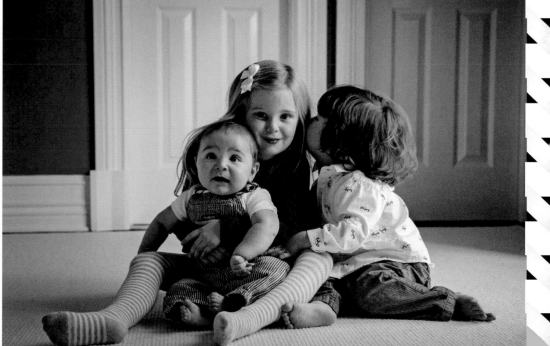

HOLIDAYS

WHEN PHOTOGRAPHING the holidays at home, some of my favorite moments are in the preparation. I like to photograph hands at work making cookies and everyone decorating the tree. To me, these photographs are more meaningful than the picture of the finished cookies or the fully decorated tree.

Since so many holiday activities seem to take place when it's dark outside, it's helpful to have a fast lens (one with a low maximum f-number that you can open very wide to let a lot of light in). Beware, though, that when you do that, your shutter speed will have to slow way down to properly expose your image. Hold your camera steady or place it on a solid surface and make sure your subject is relatively stationary. Most people will experience some camera shake (blurry pictures) at any shutter speed below 1/60 second. Another way to combat this is to crank your camera's ISO very high and accept a noisier image (see page 23).

To get that fun festive effect where your lights are all out of focus in the background (known as bokeh), place your kids a few feet in front of the lights and open your aperture as far as you can (i.e., *f*/2.8). Make sure you're focused on your child and be careful to hold the camera steady or use a tripod.

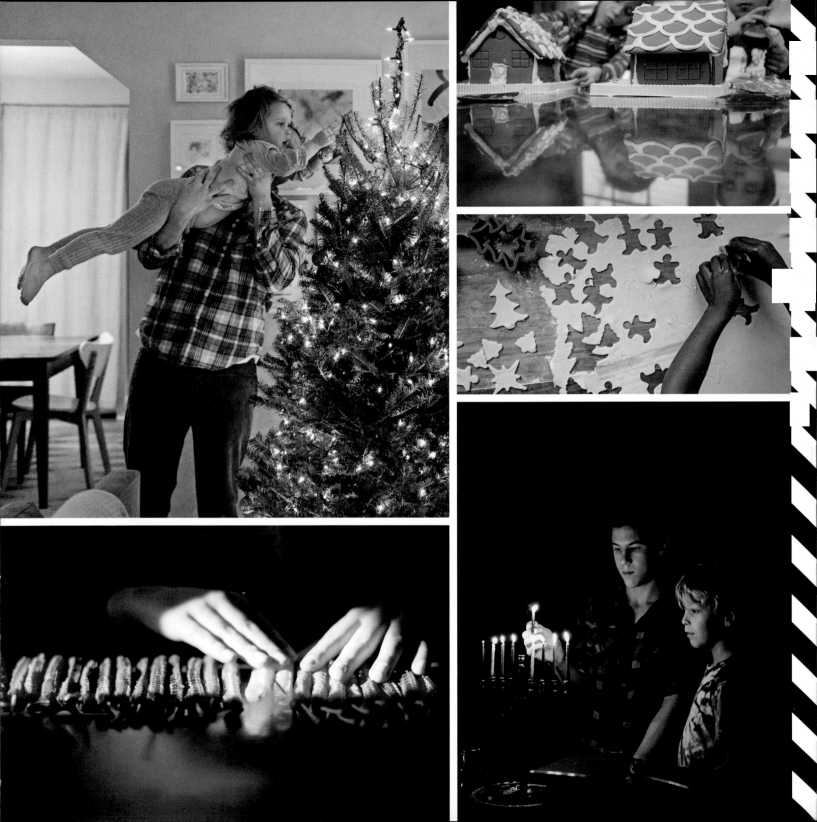

PETS

A BOOK ABOUT DOCUMENTING your family's everyday life wouldn't be complete without mention of our pets. According to the Humane Society of the United States, almost 60% of American households keep at least one kind of pet. Dogs are the most common, but cats are a close second, followed by birds, snakes, lizards, hamsters, guinea pigs, horses, and rabbits. And that doesn't even take farm animals into account. Bottom line: We love our pets. They live in our homes and sleep on our beds (admit it, you let your dog sleep on your bed) and they make us laugh, keep us company, and generally enhance our lives.

Pets are family. Most of them won't pose when we ask them to, but that's okay because to honestly depict what life with pets feels like, we don't need any posing. Everything we need for these pictures happens in our homes every day.

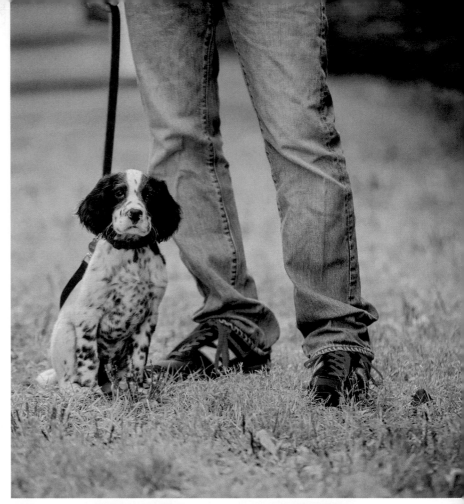

TIPS FOR PHOTOGRAPHING PETS

1. Turn Off Your Flash: If you've got a great moment all set up and framed, a flash is likely to startle your pet and ruin it. Also, pets (dogs in particular) are very susceptible to red eye. Use natural light whenever possible.

2. Macro: Get in really close or use the Macro mode on your point-and-shoot. Focus on your pet's eyes or mix it up and focus on other distinguishing features.

3. Together: Make sure to include the people who they love best in your pet photographs. Whether they're lying at your feet, licking your face, or out for a walk, we spend a lot of time with our pets. Make sure you have images that show what it felt like to live with your pet.

4. Nesting: Pets, like people, are most comfortable at home. Take advantage of this and capture them when they're still. The best photographs happen when you just look up and notice your pet being adorable. (Another good reason to always have a camera nearby.)

5. Action: To freeze the action when your pet is moving quickly, use your camera's Burst or Continuous shooting mode to take multiple consecutive images in a row. If you're shooting in Manual or Shutter-Priority mode, set your shutter to the fastest you can with the light you have available (usually higher than 1/500 second). If you're using a point-and-shoot camera, use the Sports or Action mode.

6. Personality: Every pet has their own character. Photograph your goofy dog doing his favorite trick, or your lazy cat sleeping in the sun.

7. Perspective: Vary your angle. Standing above your small pet and pointing your camera down at them will amplify their smallness, while photographing from below them will make them appear larger.

8. Snuggles: Capture a moment when they're snuggling—with each other or with us. We love to be affectionate with our furry friends.

9. Out and About: Hiking in the woods, walking along the shore or on-leash in the city, our pets are quite often our traveling companions.

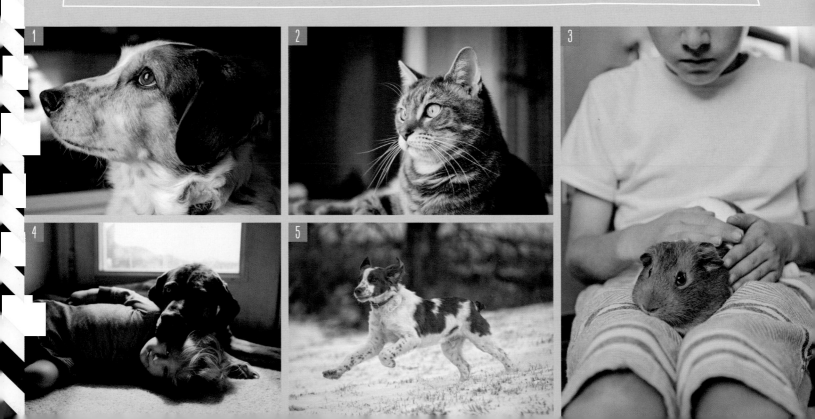

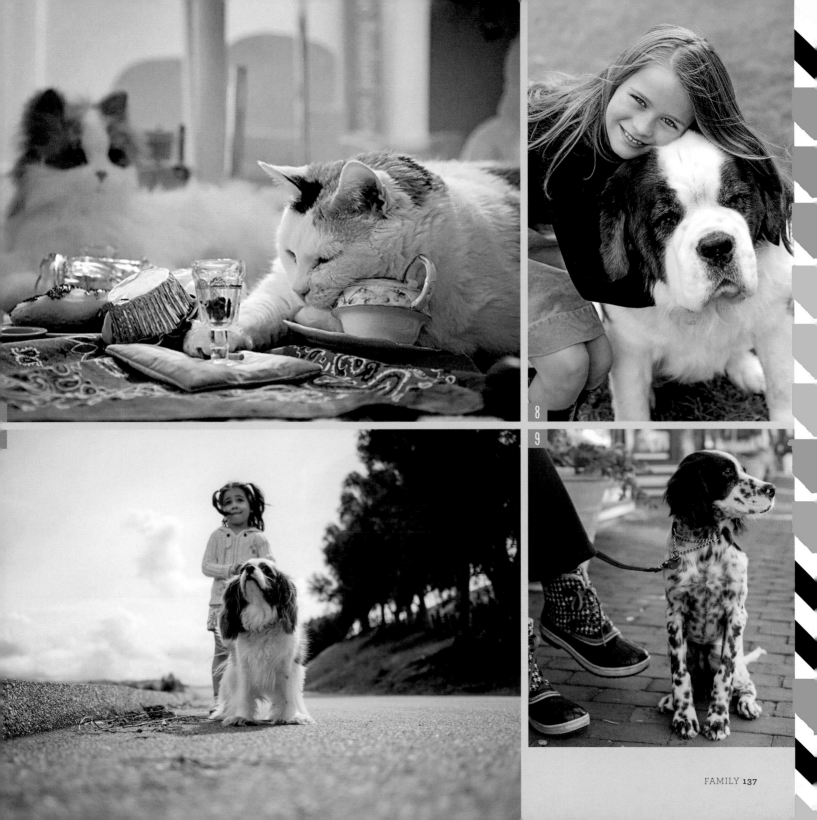

8

9

WRAPPING IT ALL UP

FAMILY PHOTOGRAPHS ARE TREASURES... but this is not news to you. Neither is it news to any parent that time travels at warp speeds when raising children. No matter how much focus we put on being present, our consciousness cannot possibly hold on to every detail. Photography gives us a way to capture moments in time and revisit them later when everything (presumably) slows down.

When I sit down years from now to pore over the pictures of my family's time at home together, I want to see all of it: the big dramatic memorable moments and the tiny, inconsequential, entirely forgettable ones. I want them all because these moments—not just the pretty ones—are the stuff of life. So yes, I pose my kids for the snapshots at the expected times and places. First day of school? I haven't missed one. However, I make a point to take out my camera during seemingly insignificant times as well, such as afternoon snack time or handwriting practice. These sweet memories will forever be brought forth when I open my photo books and flip through the pages of our days.

Look beyond the extraordinary, go deep into the ordinary for your inspiration, and there, among the routine of your every day life, you will find the story of your family. Seek it out. Experience it. Document it. And then put down your camera and drink it all in.

"PHOTOGRAPHY TAKES AN INSTANT OUT OF TIME, ALTERING LIFE BY HOLDING IT STILL." Dorothea Lange

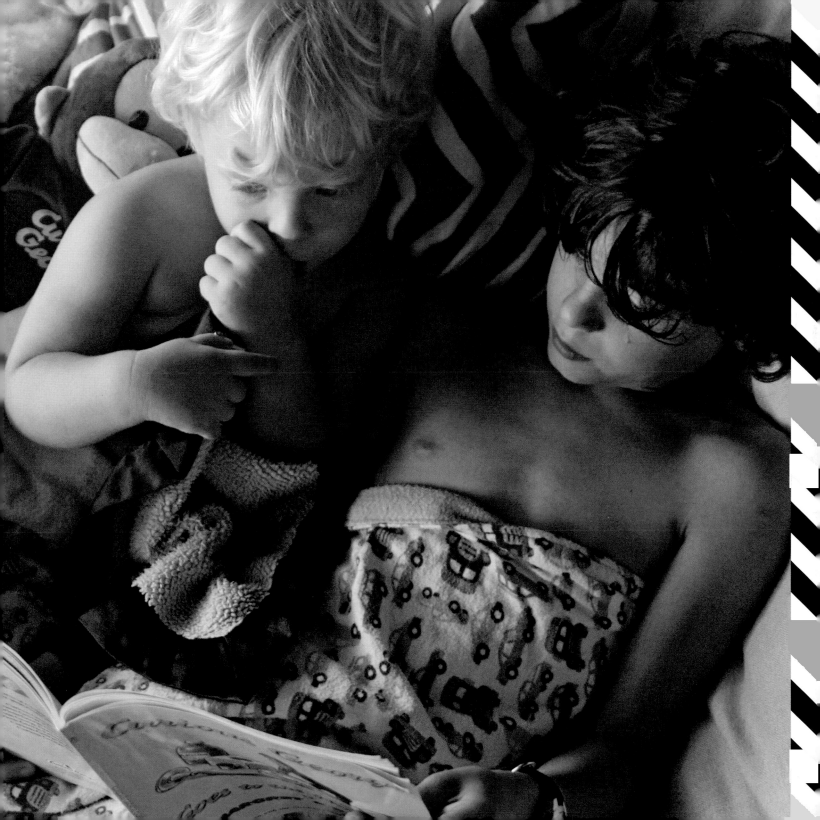

RESOURCES

Here are some helpful companies, products, and supplies that you may want to check out. There are so many choices out there, so spend a bit of time researching what might fit you and your photography style the best.

SOFTWARE

Image Editing Programs:
Adobe Photoshop Elements
Adobe Photoshop

ORGANIZATION + EDITING PROGRAMS:
Adobe Lightroom
Apple Photos

CAMERA STRAPS

Show off your personal style while carrying your camera! Replace the branded black strap that came with your camera with something that better reflects your personality.

Capturing Couture:
www.capturingcouture.com

Mod Camera Straps:
www.modstraps.com

FotoStrap:
www.fotostrap.com

Joby Camera Straps:
www.joby.com/camera-straps

Black Rapid Camera Straps:
www.black-rapid.com

Etsy:
etsy.com – Do a search for handmade camera straps for loads of gorgeous selections.

CAMERA BAGS

It's so much nicer to carry your camera around with you if you've got it tucked safely inside a bag that also doubles as your handbag. Those bulky black camera bags are a thing of the past, as many manufacturers have gotten hip to the idea that people want to carry their cameras in style. Some of my favorites are:

Ona:
www.onabags.com

Shutterbag:
www.shutterbagusa.com

Eiphanie:
www.epiphaniebags.com

Kelly Moore:
www.kellymoorebag.com

Think Tank:
www.thinktankphoto.com

Cheeky Lime:
www.cheekylime.com

Etsy:
etsy.com – Don't forget to always check for fabulous handmade options on etsy!

Tamrac:
www.tamrac.com -- Tamrac makes my newest favorite way to carry my camera a camera bag insert that fits inside a regular handbag (and it's less expensive than purchasing a regular camera bag!).

PHOTOBOOK SERVICES

Now that you've got all of those photos, put them in to books so that everyone can enjoy them! Online companies that print books either have free software you download to your computer or online software that will assist you in laying out your book. Here are some high quality and user-friendly options:

Blurb:
www.blurb.com

Pinhole Press:
www.pinholepress.com

Picaboo:
www.picaboo.com

Mixbook:
www.mixbook.com

Artifact Uprising:
www.artifactuprising. com

Groovebook:
Download the app and it will automatically send you books made from your photos at set intervals.

Apple:
Apple photo books are made from within the Pictures software on your Apple computer.

Flickr:
www.flickr.com

ONLINE PHOTO HOSTING

Most online photo-hosting services allow you to create albums and tag your photos for effective organization of your pictures. You can manipulate your privacy settings to allow for sharing of specific images and keep others private. Storing your photos online allows you to access them from your phone or tablet, but it can also serve as a backup option.

Flickr:
www.flickr.com

Amazon Prime:
www.amazon.com

Google Drive:
www.google.com/photos

Zenfolio:
www.zenfolio.com

Smugmug:
www.smugmug.com

Dropbox:
www.dropbox.com

COMPUTER BACKUP

Back. Up. Your. Photos. Enough said!

Carbonite:
www.carbonite.com

Dropbox:
www.dropbox.com

BackBlaze:
www.backblaze.com

CrashPlan:
www.code42.com/crashplan

Google Drive:
www.drive.google.com

Amazon Cloud Drive:
www.amazon.com/clouddrive/home

ONLINE LEARNING COMMUNITIES

Photography forums can be a great resource and there are thousands of them out there and new ones forming all the time. Forums can provide a community for sharing and connecting with others who are at a similar place in their photographic journey.

Clickin' Moms:
www.clickinmoms.com

Bloom:
www.thebloomforum.com

Digital Photography School:
digital-photography-school.com

Photography Concentrate:
www.photographyconcentrate.com

The Photographer Within:
thephotographerwithin.com

Search social media sites like Facebook for groups that pertain to your specific interests, or even your type of camera.

Instagram

Snapseed

Phanfare

Groovebook

Canon

Nikon

Olympus

...and so on!

The website for this book has free, printable downloadable cheat sheets to help you remember basic photo information. Visit:
www.ilexinstant.com/resources

INDEX

A
action 90–91
Adobe Lightroom 36
Adobe Photoshop 37
aperture 20–21
Apple Photos 36

B
babies 42–61
backup 40
baths 56
blur 22, 80

C
camera phone 33–34, 126
camera shake 22
cameras 32–34
city 124–125
cloud 40
composition 25, 28, 105
crawling 55
crop 105

D
depth of field 20, 21, 88
details 46

E
editing see image processing
exposure 18–19
exposure triangle 20
external hard drive 40

F
family 106–137
feeding 52
first steps 57
focus 105
focus mode 81
friends 72–73

G
gear 32

H
highlights 18–19
holidays 132–133
homework 76–77

I
image processing 36–37
ISO 23, 53, 61

K
kids 62–105

L
light 18–19, 20–21, 22, 23, 50–51, 59, 61, 82, 83, 84, 85, 105
low light 22, 23, 51

M
movement 22

N
negative space 28
newborns 42, 44
noise 23

O
outdoors 78–79, 82, 83, 84, 85, 117, 118, 119, 120, 121, 122, 123
overexposure 19

P
perspective 27
pets 134–137
photo shoot 68–69, 131
photographic theory 16
photojournalist 12
play 58, 68, 69
portraits 104–105, 130–131
printing 39

R
remote 112
Rule of Thirds 26

S
safety 48
scale 49
school 74–75
seasons 118–123
selfies 111
shadows 18–19
sharing 38

shutter speed 20, 22–23
siblings 114
silhouettes 85
sitting up 54
sleep 60
snapshot 14
software 36–37
sports 86–91
storage 40–41

T
teenagers 100–103
toys 70–71
'tweens 96–99

U
underexposure 19

V
vacation 128–129

W
water 87

PICTURE CREDITS

The publisher would like to thank the following for permission to use their images.

ACKNOWLEDGMENTS

FROM THE AUTHOR

To my children, for filling my days with beautiful chaos and challenging everything I've ever thought I knew about love. Being your mother is my life's greatest joy.

Jake, your talents humble me and your brilliance inspires me every day.

Quinn, who completed our family and makes me laugh, a lot.

To Niall, my partner, who tells me I'm smart and talented and beautiful so often that I sometimes even believe it. Thank you for loving me, and reading to our kids, and doing all of the Legos so that I don't have to.

To my father, who gave me my first camera and has never once told me I couldn't.

To my mother, who is still teaching me, by her shining example, how to be a friend, a mother, and a woman every day.

To my brother, Adam, who was the first family I ever had. I love you infinitely.

To my aunts, Jill and Beth, who are more like Bonus Mothers than anything else.

To Adam Juniper and the people at Ilex who saw the potential in what I had to say and gave me the opportunity to say it.

To Haley Steinhardt for fixing all of my mistakes and making sense out of my run-on sentences.

To Frank Gallaugher for your infinite patience with my endless questions.

To my friends at the Katonah Reading Room who gave me a comfortable place to work where there was really good coffee to keep the process moving: thank you for never asking me to "move along now."

To the many women in my life, who support me and always know just the right thing to say: I count your friendships among the most valuable things in my life.

To my clients: I thank you for inviting me into your homes and your lives and trusting me to record your precious family moments.

To my talented friends who generously allowed me to use their images to illustrate my thoughts throughout this book. Thank you to: Lindsay Crandall, Jaye McLaughlin, Amy Bader, Tara Romasanta, Elaine Heintz, Gina Cooperman, Maria Pons, Christine FitzPatrick, Holly Berfield, Jaime Foran, Kelly Schwark, Deborah Candeub, and Lena Antaramian.

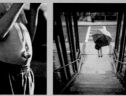